NEWPORT NEWS
THROUGH THE 20TH CENTURY

AMY WATERS YARSINSKE

AMERICA THROUGH TIME is an imprint of Fonthill Media LLC

First published 2016

Copyright © Amy Waters Yarsinske

Unless otherwise indicated in the caption, the pictures in this book are courtesy of the author.

ISBN 978-1-63499-011-0

All rights reserved. No part of this publication may be reproduced, stored in a retrieval system or transmitted in any form or by any means, electronic, mechanical, photocopying, recording or otherwise, without prior permission in writing from Fonthill Media LLC

Typeset in Rotis Serif Std

Published by Arcadia Publishing by arrangement with Fonthill Media LLC
For all general information, please contact Arcadia Publishing:
Telephone: 843-853-2070
Fax: 843-853-0044
E-mail: sales@arcadiapublishing.com
For customer service and orders:
Toll-Free 1-888-313-2665

Visit us on the internet at www.arcadiapublishing.com

Printed and bound by CPI Group (UK) Ltd, Croydon, CR0 4YY

Contents

Introduction		4
I	A New City, A New Century	13
II	The Huntington Enterprise Flourishes	49
III	A City in Depression and War	79
IV	Growth and Change	107
V	Toward a New Millennia	122
Endnotes		141
Bibliography		142
About the Author		144

Introduction

The city of Newport News, Virginia, was incorporated[1] in 1896 but had been in development since 1880 when Collis Potter Huntington began his extension of the Chesapeake and Ohio Railway system to Hampton Roads, in the lower Chesapeake Bay. Huntington's railroad extension to the southeast opened up the rich coal fields of West Virginia to broader trade outlets, but also and perhaps most importantly, opened Huntington's imagination to an entirely new industry to diversify and invest his wealth beyond rail and coal: shipbuilding. With the Chesapeake & Ohio's eastern terminus extended by 1873 to Richmond, at the head of the tidewater navigation on the James River, Huntington and his associates understood that the true potential and ultimately the long-term success of their enterprise rested on being able to extend the railroad to a suitable harbor on the Chesapeake Bay and its tributaries, one readily accessible and with depth of water for oceangoing vessels. The annual report of the Chesapeake & Ohio for the fiscal year that ended September 30, 1880, documented the research and deliberations that went into the decision that authorized him to acquire sufficient land and waterfront at Newport New Point, fronting on Hampton Roads, at the confluence of the James River with the waters of the bay. "This is a point," he would observe, "so designed and adapted by Nature, that it will require comparatively little at the hands of man to fit it for our purposes. The roadstead—Hampton [Roads]—well-known," he continued, "in maritime circles, is large enough to float the ocean commerce of the world; it is easily approached in all winds and weather, without pilot or tow; it is never troubled by ice, and there is enough water to float any ship that sails the seas, and at the same time it is so sheltered that vessels can lie there in perfect safety at all seasons of the year." Huntington reported that lands had been secured with considerable frontage on deep water, and that two wharves had been contracted.

Trains were operating over the seventy-four miles of new rails from Richmond down the Peninsula to Newport News in time for the Yorktown centennial on October 18, 1881, and the official opening of the railway soon followed on May 1, 1882. Though coal was king, tobacco and general merchandise were also moving through the Chesapeake & Ohio covered pier, in operation before the end of 1882. Huntington's report at the end of that year indicated the completion of the general merchandise pier, 700 feet in length and abutting 27 feet of water, and an 825-foot coal pier fronting on 30 feet of water that could take on six ships moored and taking on coal at the same time. Over 100,000 tons of coal were loaded in only part of the year. One of Huntington's most difficult lessons learned had been the loss of land to complete a prior venture and he determined that this would not happen again

at Newport News. In 1880, he established the Old Dominion Land Company and moved forward quickly to acquire land in the vicinity of the Chesapeake & Ohio coal and general merchandise piers. After amassing substantial real estate holdings, Huntington set about platting the land for residential and business uses but he also planned for the city that he saw one day developing around the waterfront and beyond. The May 1903 map shown herein demonstrates the progress achieved in the twenty-year period from Huntington's original charting of Newport News and the expansive holdings of the Old Dominion Land Company.

In 1886, Huntington would launch what is arguably the greatest and most enduring of his enterprises: Newport News Shipbuilding and Dry Dock Company (called Chesapeake Dry Dock and Construction Company when it was first established). Huntington ultimately understood that to ensure the success of the rail-to-sea connection there must be a merchant marine capable of carrying the country's rich products to the far corners of the earth. To make that dream come true, he needed a shipyard capable of building cargo ships, as well as of repairing and servicing them, located at an accessible port on the Atlantic Coast with deep water and Newport News perfectly fit his vision. In Huntington's own words, it was "At the very gateway of the sea, with a wide and safe entrance and commodious harbor [...] in the center of the Atlantic coast line of this great republic."[2] Bit by bit, in retrospect, the Huntington plan unfolded with each additional building, each shop, each new facility. But equally prophetic, some might observe later, were Huntington's fears, betrayed when he expressed his hopes for the yard; it was on the occasion of the launching of *El Sud*, first of the long line of modern ships built there, that he said: "... it matters little in what part of the country these ships are built, so that the flag of our common country floats over them," he continued, "... Let us learn to look upon that ensign as not so much the emblem of war as the signal of peace. Let us hope that, in the future, the ships over which it floats may carry not soldiers nor munitions of war, but the products of American industry."[3]

Huntington's shipyard was unique for the time frame in which it came on the scene; it did not develop slowly with the years but was launched as an almost complete plant into the maritime industry, observed Howard J. Balison in his narrative of the shipyard in the world wars. After the yard completed its first dry dock in 1889, it took little time for it to grow exponentially in its importance and service to the nation, including construction of a continuous succession of transport ships and nearly every class of ship for the United States Navy and critical to national defense. Huntington's hopes for his shipyard to stay out of the warship business dissipated quickly when the yard was called upon to build large naval vessels. Soon came great United States Navy ships that would leave the ways at Newport News Shipbuilding and into the history books: *Nashville, Fanning, Dallas, Houston, Ranger, Boise, Yorktown, Enterprise, Hornet* and too many more to name. With every page of history written by great ships and the men who sailed them, would be the men and, later women, who built them.

The story of Newport News Shipbuilding carries through the city for which this great American company is named. Those who would settle the former farmland around the Hotel Warwick, the Chesapeake & Ohio coal and merchandise piers and Newport News Shipbuilding were drawn to the same promise and good fortune that Collis Huntington hoped would unfold, whether he was there to see it or not. Huntington died on August 21, 1900, at Pine Knot, his camp in the Adirondack Mountains of New York, just four years after the act to incorporate the city of Newport News in the county of Warwick was approved by the Virginia General Assembly. Plans for the city of Newport News called for the laying out of particular streets and roads, starting with First Street at the end of Newport News Point. The Yorktown centennial of 1881 influenced the names of two important avenues in the

new town: Washington and Lafayette; it was not until three years after Huntington's death and seven years after Newport News had become a city that Lafayette Avenue was officially renamed Huntington Avenue (shown on the May 1903 map herein).[4] After his death, Collis Huntington's nephew, Henry Edwards Huntington, and his stepson, Archer Milton Huntington, continued his work at Newport News, and all three are considered founding fathers in the community, with local features named in honor of each.

Huntington's legacy is much greater than a street name. Today, much of the railroad and industrial development Collis P. Huntington envisioned and led are still important enterprises in the early twenty-first century. The Southern Pacific is now part of the Union Pacific Railroad, and the Chesapeake & Ohio became part of CSX Transportation, each major American railroad systems. West Virginia coal still rides the rails to be loaded aboard colliers at Hampton Roads, where nearby, Huntington Ingalls Industries (HII) operates the massive shipyard that the company calls "800 acres of the most important real estate in America." Huntington Ingalls was formerly known as Northrop Grumman Shipbuilding (NGSB) Newport News, created on January 28, 2008, by the merger of Northrop Grumman's two shipbuilding sectors, Northrop Grumman Ship Systems and Northrop Grumman Newport News. The company takes its name from the founders of its two main facilities: Collis P. Huntington at Newport News and Robert Ingalls at Pascagoula, Mississippi. Huntington Ingalls is the sole designer, builder, and refueler of nuclear-powered aircraft carriers in the United States, and it is one of two nuclear-powered submarine builders. Seventy percent of the current, active United States Navy fleet has been built by Huntington Ingalls erstwhile units. Headquartered at Newport News, Huntington Ingalls Industries is America's largest military shipbuilding company and a provider of manufacturing, engineering and management services to the nuclear energy, oil and gas markets. For more than a century, the company, with its beginnings at Newport News Shipbuilding and Dry Dock, has built—with the Mississippi division—more ships in more ship classes than any other naval shipbuilder in the United States.

This history of Newport News is about a new city in a new century—the twentieth century—with attention to the importance to the first years after incorporation to the nascent years of the twenty-first century. There is little argument that the twentieth century was "America's century," a time of incredible growth, innovation and prosperity across the country, despite depression and war, and the dichotomy of black and white, poverty and wealth that marked the highs and lows of Newport News' twentieth century experience. The consistent threads that weave the Newport News story still hinge on the imagination, ambition and achievement of Collis Huntington; what he started at the end of the nineteenth century became a powerhouse in the twentieth.

Opposite above: Interested spectators view the official opening of Chesapeake Dry Dock and Construction Company Dry Dock 1 in April 1889. On February 17, 1890, the name changed to Newport News Shipbuilding and Dry Dock Company. *Newport News Shipbuilding.*

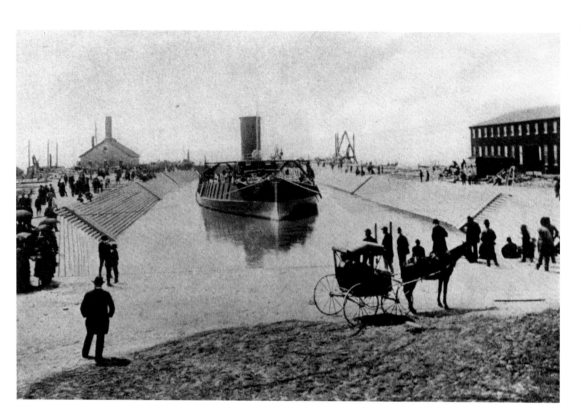

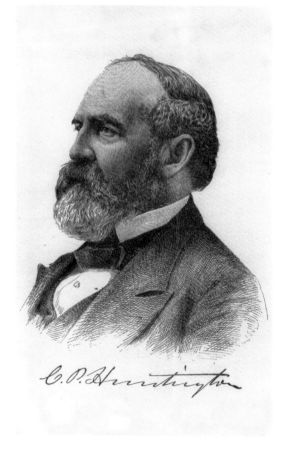

Right: Collis Potter Huntington (1821–1900) is shown in this head and shoulders portrait, facing left, in 1890. Huntington was one of the Big Four of western railroading (along with Leland Stanford, Mark Hopkins, and Charles Crocker) who built the Central Pacific Railroad as part of the first United States transcontinental railroad; he then helped lead and develop other major interstate lines such as the Southern Pacific Railroad and the Chesapeake and Ohio Railway (Chesapeake & Ohio), which he was recruited to help complete. The Chesapeake & Ohio, completed in 1873, fulfilled a long-held dream of Virginians of a rail link from the James River at Richmond to the Ohio River Valley. The new railroad facilities adjacent to the river there resulted in expansion of the former small town of Guyandotte, West Virginia, into part of a new city which was named Huntington in his honor. Next, he turned his attention to the eastern end of the line at Richmond and it is Huntington who was responsible for the Chesapeake & Ohio's Peninsula Extension in 1881/82, which opened a pathway for West Virginia bituminous coal to reach new coal piers at Hampton Roads for export shipping. He also is credited with the development of Newport News Shipbuilding and Drydock Company (called Chesapeake Dry Dock and Construction Company until February 17, 1890), as well as the incorporation of Newport News, Virginia, as a new independent city. *Library of Congress*

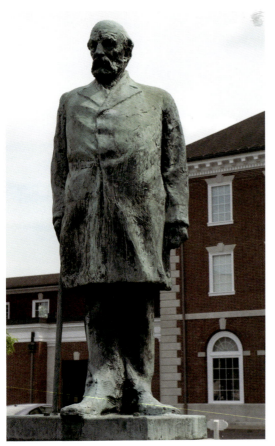

Left: This statue of Collis Potter Huntington, which stands at the restored Chesapeake & Ohio (now CSX) depot in Huntington, West Virginia, is the work of artist Gutzon Borglum, who is best-known for his sculpture of the heads of the four presidents carved in the face of Mount Rushmore in South Dakota. Huntington built the Chesapeake & Ohio Railway and founded the city of Huntington at its western terminus, just as he is credited at Newport News. On October 23, 1924, while a huge crowd looked on, the eight-foot bronze statue was unveiled and presented to the city and to the Chesapeake & Ohio. Carol M. Highsmith took this picture of Huntington's statue on May 7, 2015. *Carol M. Highsmith Archive, Library of Congress*

Below: The SS *Newport News*, flying the flag of Secretary of the Navy Hilary Abner Herbert, is shown arriving at Newport News, Virginia, on October 19, 1895, for the launchings of the USSs *Nashville* (PG-7) and *Wilmington* (PG-8). *United States Naval History and Heritage Command*

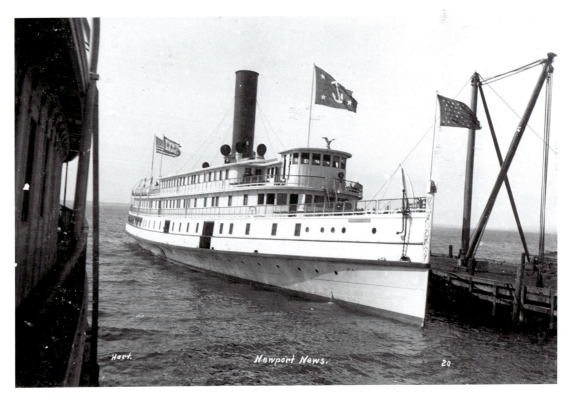

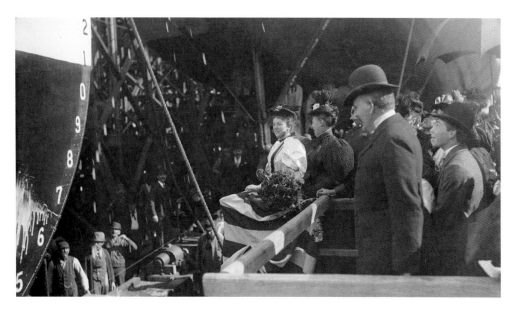

USS *Nashville* (PG-7), a gunboat, was the only ship of its class. It was the first of three ships of the United States Navy to hold the name *Nashville*. The gunboat was laid down on August 9, 1894, by Newport News Shipbuilding and Dry Dock Company, and was launched on 19 October, 1895. *Nashville* was sponsored by Miss Maria Guild (shown here, dressed in the white dress on the platform in this Edward H. Hart photograph), and commissioned on August 19, 1897, Commander Washburn Maynard in command. Upon commissioning, *Nashville* joined the North Atlantic Fleet and, as war with Spain became imminent after the sinking of the armored cruiser USS *Maine* (ACR-1), she was ordered to the Caribbean. She captured four Spanish vessels from April 22 to July 26, 1898, and assisted in cutting the undersea telegraph cable just off the shore of Cienfuegos, where many of her sailors and Marines were honored with Medals of Honor. *Nashville* remained on duty off Cuba until the war's end; the ship was decommissioned on October 21, 1918. Maria was the daughter of Nashville mayor George Blackmore Guild. *Library of Congress*

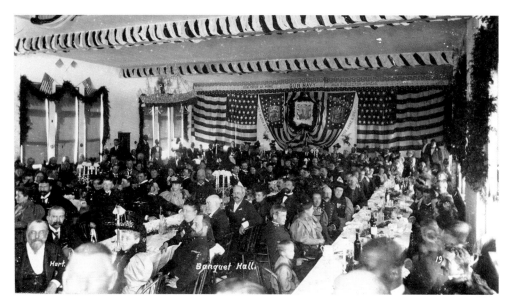

Newport News Shipbuilding and Dry Dock Company launched two ships on October 19, 1895. The USS *Nashville*'s sister ship was USS *Wilmington* (PG-8). The sponsors' banquet for the launching of USSs *Nashville* and *Wilmington* was held at Newport News that day and is shown in this picture taken by noted maritime photographer Edward H. Hart, of New York. *United States Naval History and Heritage Command*

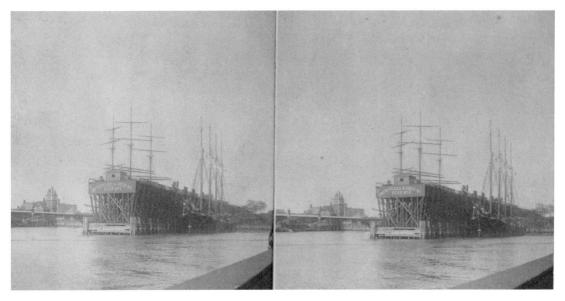

Alfred S. Campbell took this 1897 photograph of the Chesapeake and Ohio Railway Pier 2 for the stereograph shown here. The railroad's passenger terminal was at the other end of this pier. *Library of Congress*

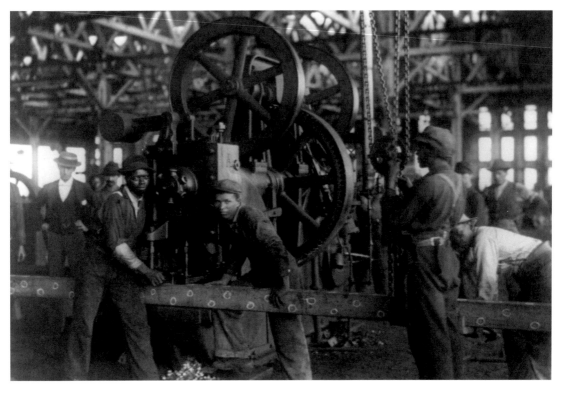

Newport News photographer Samuel E. Rusk took this picture at Newport News Shipbuilding and Dry Dock Company of black workers punching single metal bars for the United States battleship *Illinois* (BB-7), under construction at the shipyard just then. The *Illinois* (hull number 21) was launched on October 4, 1898, before a large crowd; a banquet was held at Hampton's Hotel Chamberlin for dignitaries, ship's officers and invited

The Pennsylvania Volunteer Cavalry, under the command of army major Charles S. W. Jones, are shown here making their way from the Newport News stockyards to the army transport *Manitoba*. Although these volunteers were mustered at Newport News on July 27, 1898, for immediate departure, the ship was not ready and 800 men, including 80 officers, 1,000 horses and mules and 1,280 tons of supplies were delayed in the summer heat until August 5, when the Pennsylvania volunteers boarded *Manitoba*, departing the James River for Puerto Rico. This stereoview was published in 1899. *Library of Congress*

Black students from Hampton Institute were working at Newport News Shipbuilding and Dry Dock Company on a schooner when Frances Benjamin Johnston (1864–1952) took their picture in 1899. *Library of Congress*

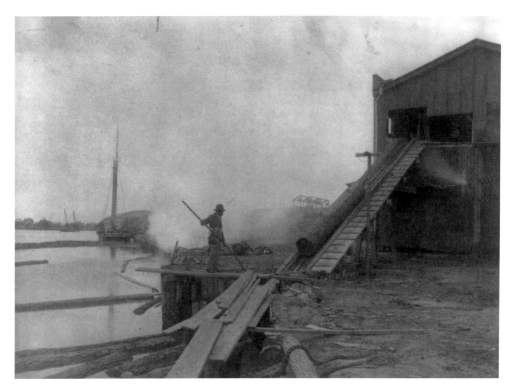

Frances Benjamin Johnston took this picture of a black man guiding a log from the water onto a saw mill ramp in 1899; the backdrop is the James River. *Library of Congress*

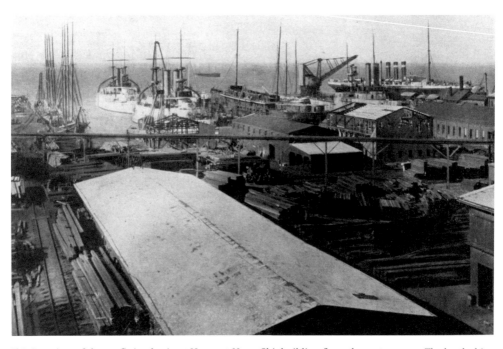

This is a view of the outfitting basin at Newport News Shipbuilding from the water tower. The battleships *Kearsarge* (BB-5) and *Kentucky* (BB-6) are at Pier 2 with the second *El Cid* (hull number 27), and *Comus* (hull number 28), on the far side of the pier. The battleship *Illinois* (BB-7), lead ship of its class, is at Pier 3, while luxury liner *New York* of the American Line lies at Pier 4. The picture was taken in December 1899. *Newport News Shipbuilding*

I

A NEW CITY, A NEW CENTURY

To facilitate the extension of the Chesapeake and Ohio Railway to Newport News, Collis Huntington needed more than a quiet post Civil War hamlet that consisted of vast farmland and a sleepy fishing village to match his expectation for a thriving industrial center on the Virginia Peninsula. The Old Dominion Land Company was Huntington's answer. Established in 1880, it was formed primarily to lay out the metropolis and before the end of 1882 a cluster of buildings had been completed, including a hotel, the Lafayette House at the northeast corner of Twenty-seventh Street and what was then Lafayette Avenue (later renamed Huntington Avenue in tribute to the shipyard's founder). A larger hotel, the original Hotel Warwick, opened for business in April 1883.

As the shipyard began to take shape, new and more conveniently located residential sections were built to accommodate a population that up to that point had been confined to an area adjacent to the Chesapeake and Ohio piers. New neighborhoods grew in number and size, the influence of the shipyard on colloquial names for each was evident: "Dry Dock Row," "Bosses' Row," "Quality Row," "Whiskey Row," "Stable Row," and several others.[5] The real life of the shipyard—and vicariously Newport News—started on April 24, 1889, with the official opening of its first dry dock. "The opening...marks a new era," according to newspapers of the day, "in the industries of Virginia and will also have an important bearing upon the shipbuilding interests of the country." The vessel selected for testing the dry dock was the naval monitor USS *Puritan* (BM-1), the heaviest concentration of weight available but taking no chances, yard officials tried out the dry dock a few days earlier, on April 19, by docking the dredge *Commodore* and the British steamer *Wylo*, to ensure the dock would not disappoint on its official opening day.

The shipyard came on the scene during the transition period between sail and steam, and many clipper ships and barques made the way up the James River in those early days, including the *George M. Grant*, the *Lyman N. Law*, the four-masted steel barque *North Star*, the William F. Palmer fleet, of white-hulled coal colliers, the seven-masted schooner *Thomas W. Lawson*, the old wooden-hulled frigate *Jamestown*, built in 1845, and many others. Despite the shipyard's repair and conversion in 1894 of the 3,900-ton British steamer *Persian Monarch* to a square-rigged sailing ship, it was clear that the age of sail and of wooden-hulled commercial sailing ships was over. Transoceanic vessels put into Newport News for repairs. Shipyard history documents the *Atlantic Greyhound*, a 10,500-ton luxury ship that was one of the notable vessels of its time; the 11,600-ton *Saint Paul*, the 20,000-ton sister ships *Minnesota* and *Dakota*, the *Mongolia* and *Manchuria*. The international

significance of these ships at that time may best be judged, according to yard documentation, by the fact that forty years would pass before there lay at the same piers the United States's own 35,000-ton *America*, largest merchant vessel ever constructed in the country up to that time. Constructed, it would be noted, just in time to play a crucial role in the nation's history.

Newport News Shipbuilding's naval building program began with the delivery by the shipyard of the gunboat USS *Nashville* (PG-7), the vessel that would go on to fire the first shot of the Spanish-American War. The date October 19, 1895, was significant for Newport News and the shipyard—and the nation—with the unprecedented double-launching of *Nashville* and USS *Wilmington* (PG-8), twin-screw vessels with quadruple-expansion engines, and the top of the line of naval ships when built. The double launching was celebrated on the one hundred fourteenth anniversary of the close of the Revolutionary War. In the river opposite the shipyard was the White Squadron, six large flag-bedecked vessels of the Atlantic Fleet, that rode anchor and added to the colorful spectacle for those who watched events of the day unfold on shore.

When the nascent city of Newport News was incorporated in 1896 with Walter A. Post as the first mayor, the population was just over nine thousand, a figure that nearly doubled from 1890, when the town fell within the bounds of Warwick County. The common council adopted an official city seal bearing the motto *Magni Dei Datum*, translated "Gift of the Great God," on May 19, 1896. Though the Newport News Light and Water Company had been chartered in 1889, the unincorporated town needed a police department, which it got in 1894. Beyond a police department, which preceded the formation of the city by two years, burgeoning Newport News had other issues that needed to be addressed, from construction of schools to bridges, sewer lines, garbage disposal, a jail, a hospital and potable water.

The community's rapid growth from post-Civil War rural plantations and a small fishing village made it necessary to make improvements and provide services to those now drawn to the opportunities created by men like Huntington and Post, men who came to the new city confident that rail and water equated to prosperity for all. Walter Post's arrival in Newport News, sent by his brother-in-law, Eugene White of Brooklyn, who had contracted with railroad magnate Huntington to build the new Chesapeake and Ohio Railway terminal, spoke to those drawn to the lucrative coal business on the Virginia Peninsula and to whatever further opportunities might come—and they did. In 1911, Post assumed the presidency of Newport News Shipbuilding and Dry Dock Company; as the first resident president he would hold that office until his death the following year. The newspapers of the day attributed his death to "overwork." After Post's death, Collis Huntington's nephew, Henry Huntington, took over as president of the shipyard, a position he held until 1914. Huntington Park, developed after World War I near the northern terminus of the James River Bridge, is named in his honor.

The city was only two years old when the Spanish-American War broke out and it became a primary port of embarkation for the invasion of Spain's territories in the West Indies, to include Cuba and Puerto Rico. Newport News Shipbuilding launched its first battleships, the USSs *Kearsarge* (BB-5) and *Kentucky* (BB-6). *Kearsarge* was the lead ship of her class of pre-dreadnought battleships; *Kentucky* was the second. The *Kearsarge*'s and *Kentucky*'s keels were laid down on June 30, 1896, and both ships launched on March 24, 1898. Neither ship was commissioned in time to see service in the Spanish-American War and neither saw combat. *Kearsarge*-class battleships were built for coastal defense.

By the time of the Spanish-American War, public health issues were of great concern at Newport News, most especially when hot, humid summer multiplied the flies, mosquitoes and vermin from the waterfront docks to homes and businesses in town. There was a

yellow fever outbreak in 1899 that prompted an exodus from the city; ground zero for the illness turned out to be polluted water from a cistern at the Old Soldiers' Home in Phoebus, contaminated by rats. Due to the number of residents who attempted to leave Newport News and Hampton, a quarantine boundary was set up between Newport News and what was then Elizabeth City County (absorbed by Hampton, the county seat, in 1952).

Aside from the pestilence that plagued the new city, humanity's castoffs settled in an area that came to be known significantly as Hell's Half Acre, a district between Eighteenth and Twenty-third Streets adjacent to the Chesapeake and Ohio piers, later razed and occupied by a railway yard. When Newport News was incorporated as a city in 1896, Hell's Half Acre lay outside its limits. Shacks were hurriedly built to house its disparate population, estimated during World War I at about two thousand persons almost equally divided between blacks and whites, whose barrooms and brothels catered to waterfront workers and visiting seamen. The area purportedly averaged a murder a week. At the end of the war Newport News annexed Hell's Half Acre and the adjacent black district known as Poverty Row, and instituted a program of law enforcement to control crime that raged out of control. Between 1925 and 1927 all the land of both sections was bought by the Chesapeake and Ohio Railway, and the disreputable shanties razed.[6] The deplorable conditions in Hell's Half Acre weren't missed. But it wasn't the last of the disreputable hovels to spring up near the waterfront. Just before America entered World War I in 1917, another section, given the grim name Bloodfield, was located just outside the city limits. To rid itself of Bloodfield and the rampant crime that flowed from it, the city expanded its boundary from Twentieth Street, between Marshall Avenue and the Chesapeake and Ohio right of way, to the low-water mark on Hampton Roads and the James River. The extension also brought the municipal small boat harbor into the city limits. The annexations that took place to eradicate the unsavory sections of Hell's Half Acre and Bloodfield were only the beginning of several greater—and some not—annexations that took place, beginning with the area between the aforementioned Fiftieth and Fifty-seventh Streets.

By the turn of the twentieth century, twenty-two amendments to the city charter were adopted by the Virginia General Assembly, most of them approving the issuance of public bonds and borrowing money to address the pressing issues of a new city in a new century. One of the amendments extended the city's boundaries to include the area between Fiftieth and Fifty-seventh Streets, then in Warwick County; this area, extending all the way from the low-water mark on the James River to the westerly boundary of the Chesapeake and Ohio right-of-way, was the nascent city's first annexation of what would be many to come.

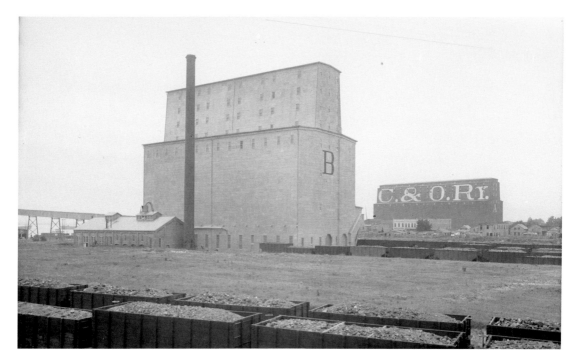

Completed in July 1884, the Chesapeake and Ohio Railway's immense Grain Elevator A (right), with a capacity of 1.5 million bushels, dominated the Newport News waterfront until it was destroyed by a September 4, 1915 fire that also burned two piers and numerous other buildings. *Detroit Publishing Company Collection, Library of Congress*

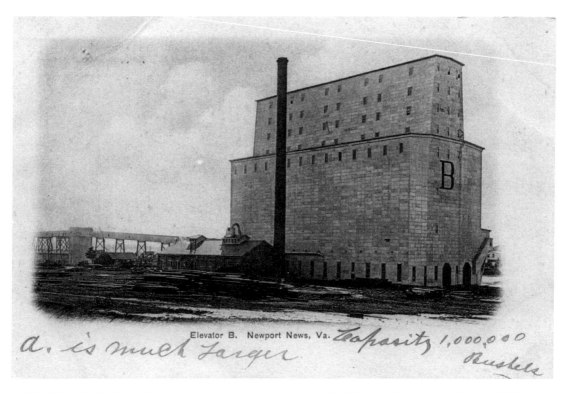

Built in 1899, this 200-foot-tall giant grain elevator—Elevator B—could hold one million bushels. Though slightly smaller than Elevator A (out of view behind Elevator B) it blew up and burned in 1934 after decades of funneling Midwestern grain to Europe. The photograph on this postcard was taken in 1900.

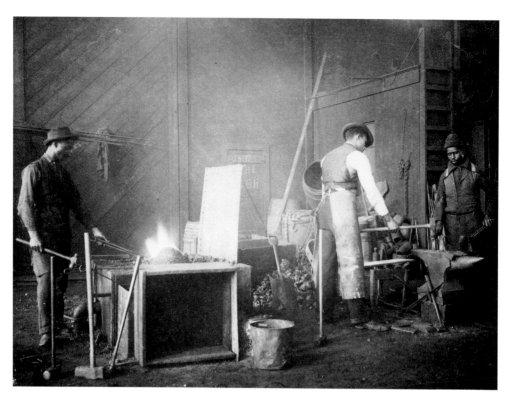

Frances Benjamin Johnston took this photograph of three men working in the blacksmith shop at Newport News Shipbuilding and Dry Dock Company in 1900. *Library of Congress*

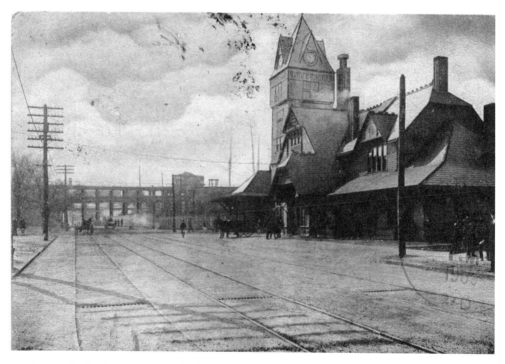

This is a north view looking toward the front of the Chesapeake and Ohio Railway station and steamship company and the Chesapeake and Ohio's pier number two; there are horse and wagon teams running back and forth to the station. The postcard on which this photograph appeared was mailed on January 27, 1909.

USS *Kearsarge* (BB-5), the lead ship of its class of pre-dreadnought battleships, was named after the sloop-of-war *Kearsarge*; its keel was laid down by Newport News Shipbuilding on June 30, 1896, and it was launched on March 24, 1898, sponsored by the wife of Rear Admiral Herbert Winslow, the former Elizabeth Maynard, and commissioned on February 20, 1900. The *Kearsarge* is shown in a photograph that dates to 1900. *Detroit Publishing Company Collection, Library of Congress*

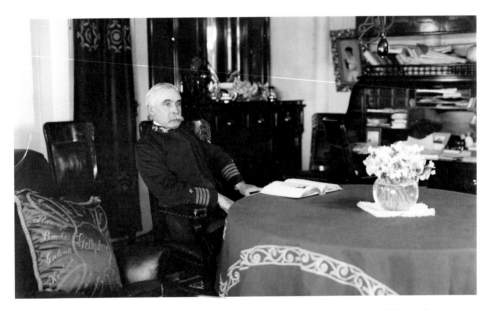

In preparation for the USS *Kentucky*'s (BB-6) christening, the United States Navy asked Kentucky governor William O'Connell Bradley to select a member of his family to perform the launch ceremony at Newport News Shipbuilding. Bradley chose his daughter, Christine, who was attending school in Washington, D.C. The Bradleys were a family of teetotalers, so Governor Bradley sent a bottle of water from Lincoln Spring in Hodgenville, Kentucky, for Christine to use at the ceremony. *Kentucky* was christened on March 24, 1898, the same day as sister ship *Kearsarge*. Soon after Miss Bradley broke the bottle of water over the *Kentucky*'s bow, a delegation from the Women's Christian Temperance Union (WCTU), led by Frances Beauchamp, presented the governor's daughter with a gift of a silver tray, a water pitcher, and two goblets. The inscription read, "Kentucky Christian Temperance Union to Miss Christine Bradley, as a tribute to her loyalty to conviction in the christening of the Battleship *Kentucky* with water [and dated] March 10, 1898." *Kentucky* was commissioned on May 15, 1900, under the command of Captain Colby Mitchell Chester (shown here, in an Edward W. Hart photograph, taken in his cabin aboard ship in 1900). *Detroit Publishing Company Collection, Library of Congress*

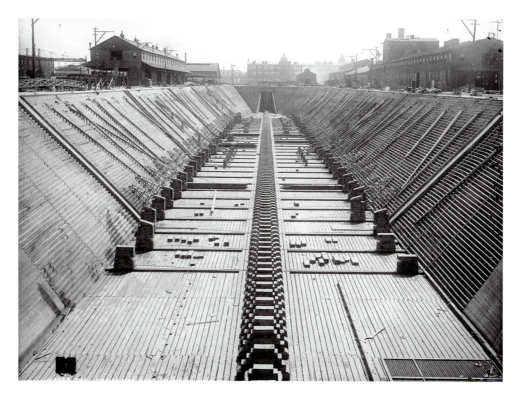

What was hailed as the largest dry dock in the world and the "wonder of the age" opened for business on April 29, 1889, at Newport News Shipbuilding and Dry Dock Company. Dry Dock 1 could handle three vessels at one time, a great achievement at that time. This picture was taken at the turn of the twentieth century by a Detroit Publishing Company photographer. The shipyard's main office building is at the head of the dry dock. *Library of Congress*

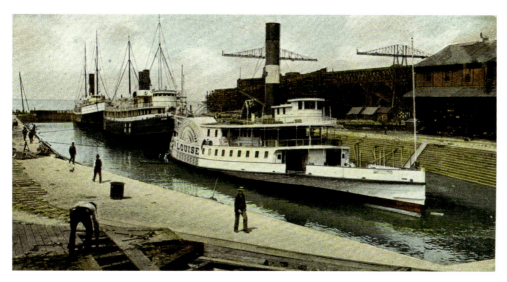

This is a Detroit Publishing Company postcard of the great dry dock—Dry Dock 2—at Newport News Shipbuilding and Dry Dock Company, taken at the turn of the twentieth century. The dry dock was under construction in June 1900, a process that required excavation to thirty-six feet below mean high water on the James River. The dry dock opened in May 1901 and is shown here (left to right) the coastal steamers *Olivette* and *Miami*, and the steamboat *Louise*. The aggregate length of these three ships was about 700 feet, which still left room to spare in the 800-foot dry dock.

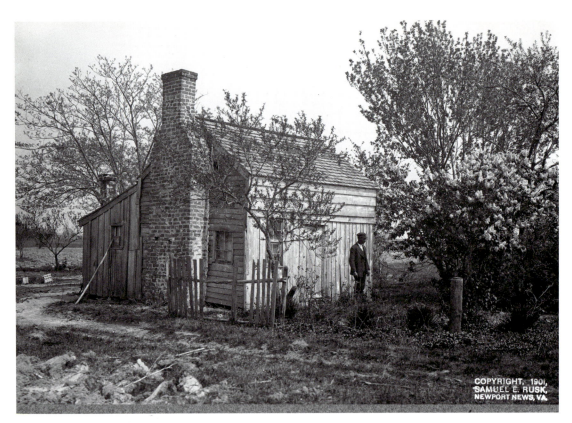

Samuel E. Rusk took this picture of a black man in front of a small house in 1901. When Collis P. Huntington established the Old Dominion Land Company in 1880, most of the residents of Newport News were African Americans who lived in the area of Eighteenth Street and River Road. There were no white schools in Newport News just then because there were so few white children; a black school was run out of a house across the Chesapeake & Ohio track near Twenty-eighth Street. *Library of Congress*

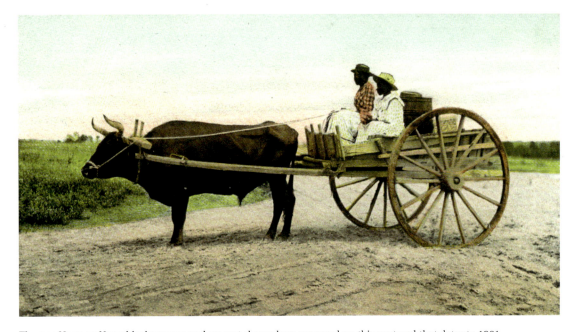

The two Newport News black women and ox cart shown here appeared on this postcard that dates to 1901.

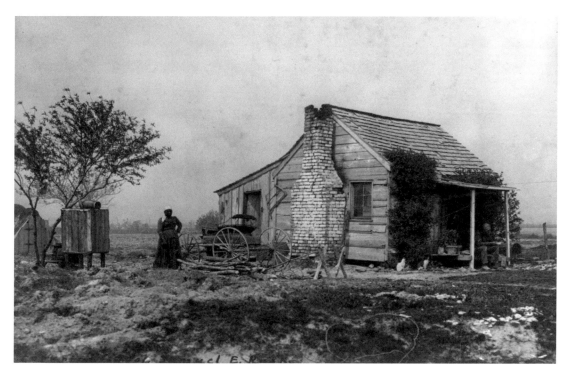

The poor conditions in which Newport News' black residents lived is shown in these Samuel E. Rusk photographs, also taken in 1901; the city waterfront is to the right of the house in the picture above. The city's black Chesapeake & Ohio laborers and also shipyard workers often walked from the ramshackle houses rented nearby and small farms a bit further out. Many of the early photographs of the Chesapeake & Ohio grain elevators show wood frame homes clustered like a small town within the bounds of the docks. Newport News was, most especially at that time, a "yard town" and the conditions for laborers, especially segregated black workers, were often less than desirable. *Library of Congress*

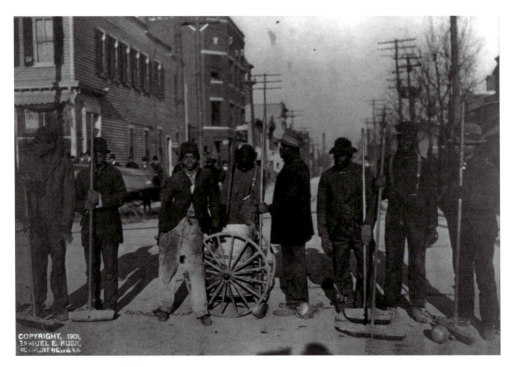

At the turn of the century a "chain gang," called by this name in a city ordinance and by the public at large, kept Newport News' streets in repair. Samuel E. Rusk took this picture of a chain gang in 1901. *Library of Congress*

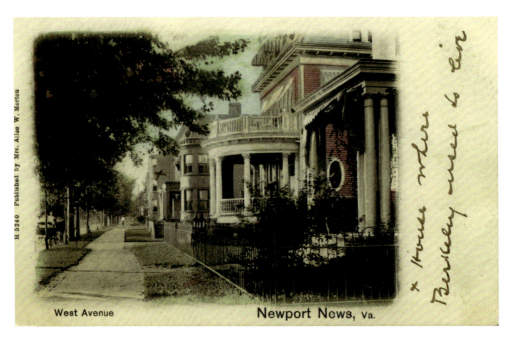

When Newport News was first laid out in the 1880s and 1890s, the favored residential thoroughfare along the James River was West Avenue. Today it is a neglected area of apartment houses and parking lots, although it was the city's social hub until well after World War I, an enclave of lawyers, judges, doctors and shipyard executives. West Avenue was no ordinary neighborhood; it extended only twelve blocks from the old Chesapeake & Ohio passenger tracks at Twenty-third Street to the eastern boundary of the shipyard at Thirty-fifth Street. On one side for most of the way were the grounds of the Casino and on the other a phalanx of three-story residences, some of which became boarding houses when the neighborhood declined.

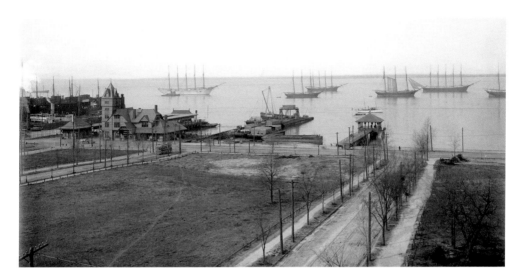

William Henry Jackson (1843–1942) took this early twentieth-century picture of Hampton Roads looking toward the Chesapeake and Ohio Railway's passenger terminal and coal piers in 1903 from the roof of the Hotel Warwick. The Peninsula Extension which created the Peninsula Subdivision of the Chesapeake & Ohio was the new railroad line on the Virginia Peninsula from Richmond to Newport News; its principal purpose was to provide an important new pathway for coal mined in West Virginia to reach the harbor of Hampton Roads for coastal and export shipping on collier ships, several of which are in this photograph. The five-masted white hull coal collier waiting for a turn at the coal pier is the *Paul Palmer*, built in 1902 by George F. Welt of Waldoboro, Maine; it was part of William F. Palmer's fleet of white hulled vessels active in the New England coal trade. Palmer sold the company to J. S. Winslow in 1911. The *Paul Palmer* was en route to Newport News when it sank on June 13, 1913. *Detroit Publishing Company Collection, Library of Congress*

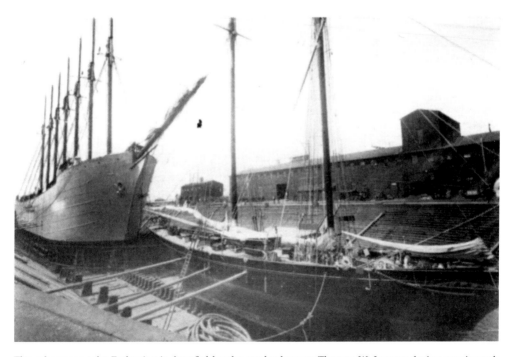

The schooner yacht *Endymion* is dwarfed by the steel schooner *Thomas W. Lawson* during repair work in Newport News Shipbuilding's Dry Dock 1 on April 16, 1903. The *Lawson* was the only seven-masted schooner ever built. The crew could not remember technical terms for the seven masts so they called them by the days of the week.

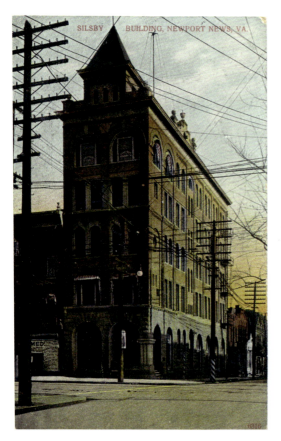

The Silsby Building shown on this early postcard housed law offices and is thus sometimes called the Law Building; it was erected at the corner of Twenty-seventh Street and Washington Avenue in 1904 by Howard Wiswell Silsby, who owned a Richmond, Virginia coal yard. This impressive structure was the first in Newport News to have an elevator. There was a unique feature to the building: a cloth-covered metal time ball that was dropped at noon daily from the pole seen at the top of the building. Seamen set their clocks by this device until it was dismantled in the 1950s. The Silsby was torn down in 1963.

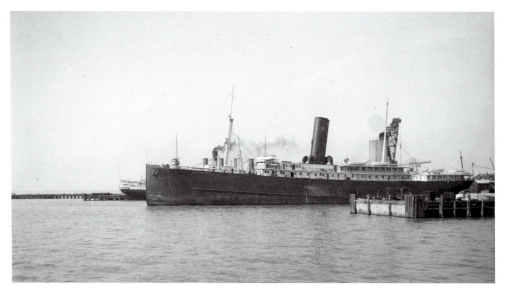

The SS *San Jacinto*, a combination passenger and freight steamer, was built in 1903 by the Delaware River Iron Ship Building and Engine Works, of Chester, Pennsylvania, for the Mallory Steamship Company; it was a jewel in the crown for the "Mallorys of Mystic" and is shown in this 1904 Detroit Publishing Company photograph taken while it was on a stopover at the Newport News Shipbuilding and Dry Dock Company, presumably for outfitting. The steamer was chartered by the United States Army during World War I. In 1935, the *San Jacinto* operated under the auspices of the New York and Porto Rico Steamship Company of New York; it was torpedoed and sunk by the German submarine *U-201* off Cape Hatteras on April 22, 1942. *Library of Congress*

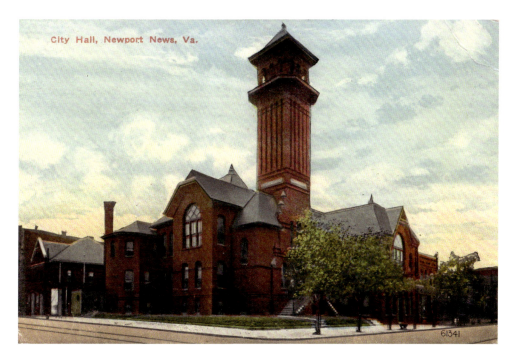

The Warwick County Court moved from Denbigh to Newport News in 1888. The Court House Building shown in this image was built in 1891 at the corner of Lafayette (later Huntington) Avenue and Twenty-fifth Street, and served as the county court house until 1896 when Newport News incorporated as an independent city. This court house building served the city of Newport News until 1948. The postcard dates to 1905.

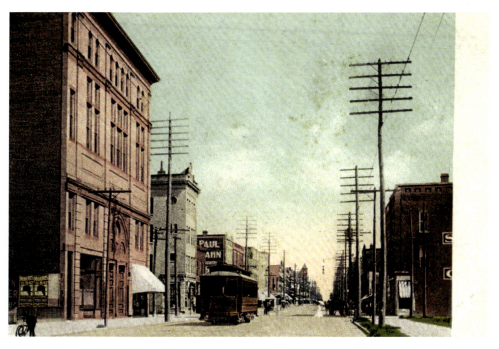

This is an image of Newport News' main business district on Washington Avenue. Note the streetcar and the size and many levels of the utility poles. The original Detroit Publishing Company photograph and the postcard made from it date to 1905. Washington Avenue received its name from the Old Dominion Land Company in 1881 in honor of General George Washington and during the centennial commemoration of the Battle of Yorktown. Washington Avenue became the heart of the business district in the city.

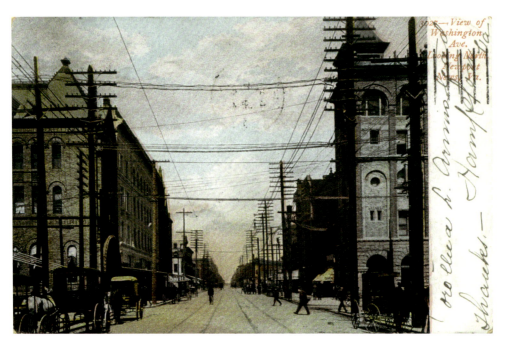

This postcard, which dates to 1905, is a view of Washington Avenue looking north from Twenty-sixth Street. Note the horse drawn carriages and the height of the utility poles.

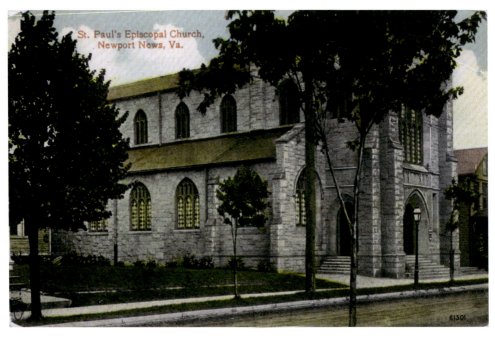

In 1899, the original Saint Paul's Episcopal Church building on Twenty-fifth Street was moved to the present Thirty-fourth Street location (shown here). American architect P. T. Thornton Marye designed the neo-gothic stone building built between 1899 and 1900. The church, with a 40-foot ceiling and pine floors, features a marble altar designed by Italian artisans. The worship space is dominated by a signed, five-panel chancel window designed and installed by the Louis C. Tiffany Studios of New York. The cornerstone of the present church building was laid in on All Saints' Day, November 1, 1899, and the first service in the new building took place on Easter Sunday, April 5, 1900. When the new church was completed, the old frame church building was used as a parish house until it, too, was replaced by a brick structure in 1916.

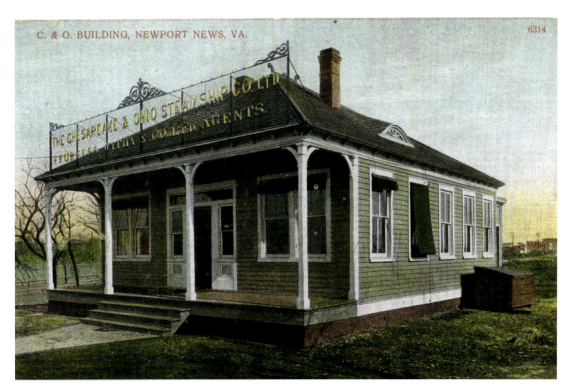

This three-quarter view of the Chesapeake and Ohio Steamship Company Limited office building with outside coal bin has a sign overhead that reads "Furness Withy & Co., Ltd. Agents." The building, shown on this 1905 period postcard, was located on River Road opposite the Chesapeake & Ohio passenger station.

A Detroit Publishing Company photographer took this picture of the Chesapeake and Ohio piers in 1905. *Library of Congress*

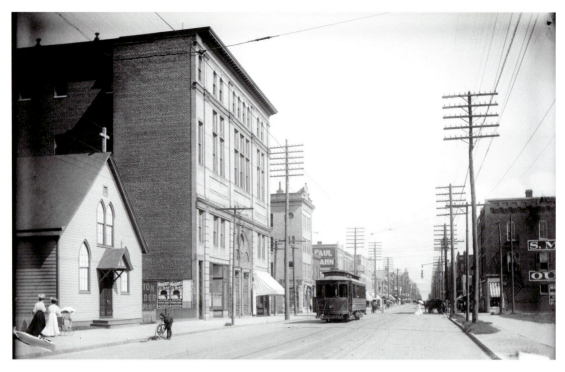

This is Washington Avenue on a hot summer's day in 1905, taken by a Detroit Publishing Company photographer from Twenty-seventh Street. In the middle of the picture, left (beyond the streetcar) is the Lexington Hotel, which was located on the corner of Thirty-first Street and Washington Avenue; across the street was the Citizen's Railway Light and Power Company located at 3025 Washington Avenue. This company began in 1898 as the Peninsula Railway Company; the name was changed to Citizen's in 1900 by president Walter A. Post. *Library of Congress*

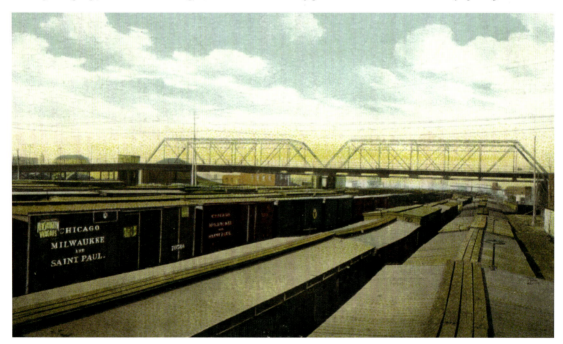

The Chesapeake and Ohio rail yard, looking towards the Twenty-eighth Street Bridge, appeared on this 1905 period postcard. This was a coal storage yard that extended under the bridge. Note the Chicago, Milwaukee and Saint Paul rail cars left, foreground.

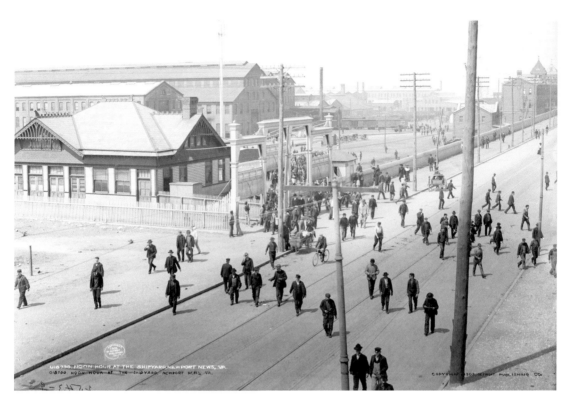

The subject of this 1905 Detroit Publishing Company photograph is the noon hour at Newport News Shipbuilding and Dry Dock Company, as workers and customers pass in and out of the main entrance gate at Thirty-seventh Street at lunchtime. *Library of Congress*

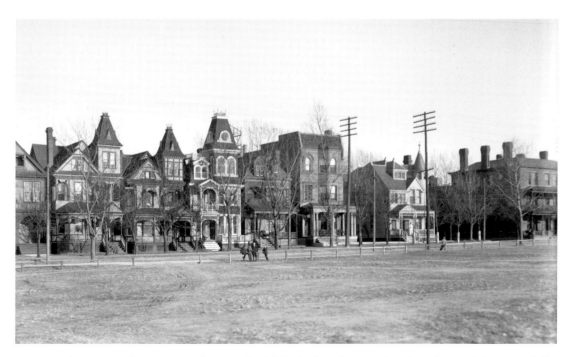

West Avenue was Newport News' choice residential district from the 1890s into the early twentieth century. Sadly, there are only two structures still standing in this row of elegant and beautifully detailed homes, situated between what is today West Avenue between Twenty-ninth and Thirtieth Streets.

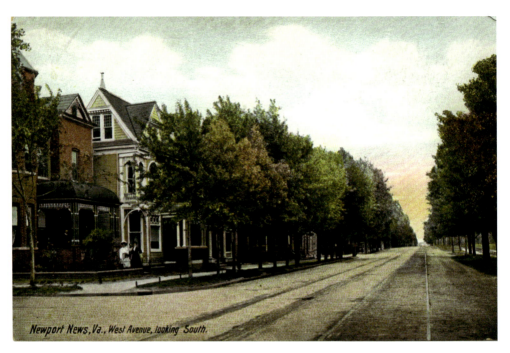

This is the 3200-block of West Avenue looking south. None of the residences, then on the trolley line, are still standing. Newport News mayor Harry Reyner, a ships' chandler, lived on this block. Today, Eddie's Restaurant sits approximately where the homes in the foreground once stood.

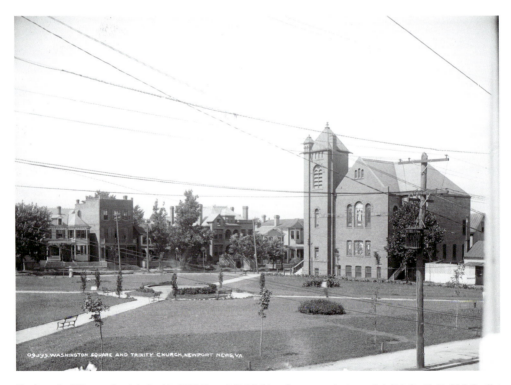

The large building to the right in this 1905 Detroit Publishing Company photograph is Trinity United Methodist Church, fronting Twenty-ninth Street on Washington Square. The square was located on Washington Avenue between Twenty-eighth and Twenty-ninth Streets, and was outlined in Norwegian elms. Washington Square was razed in 1936 to make way for commercial development. *Library of Congress*

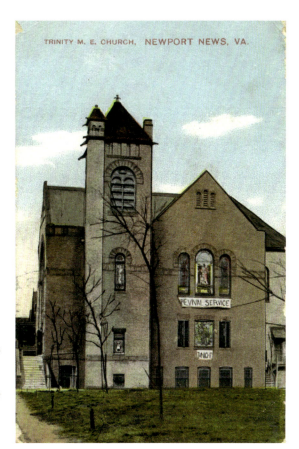

Trinity United Methodist Church, on Twenty-ninth Street and Washington Square, was advertising a revival service on the banner hung below a grouping of three of the church's 32 Louis Comfort Tiffany stained glass windows. The structure shown on this 1907 postcard dates to 1900 and is the second building occupied by the Trinity United Methodist congregation.

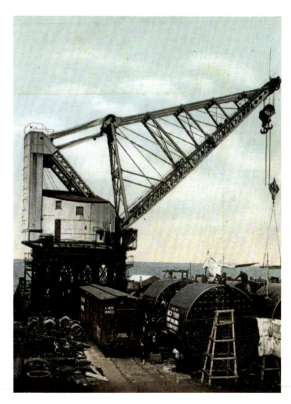

The great crane "Hercules" at Newport News Shipbuilding and Dry Dock Company is shown on this 1905 Detroit Publishing Company postcard.

This is the main entrance of Newport News Shipbuilding and Dry Dock Company as it looked in 1905; it is located, just as it was then, at Thirty-seventh Street and Washington Avenue. The main office building is the twin-tower building far right.

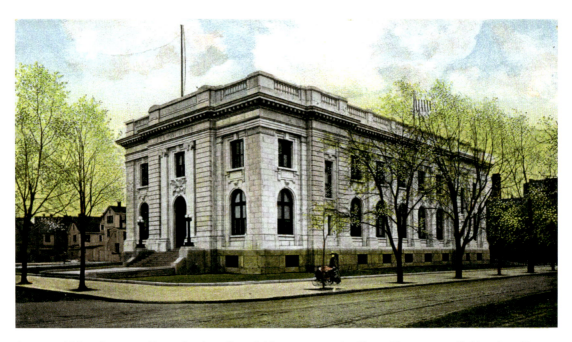

A young girl from Pottstown, Pennsylvania, collected this 1905 postcard, addressed but never mailed it to herself in February 1907; it shows the U.S. custom house and post office, completed and occupied on June 1, 1904; the building is located on West Avenue between Twenty-fifth and Twenty-sixth Streets.

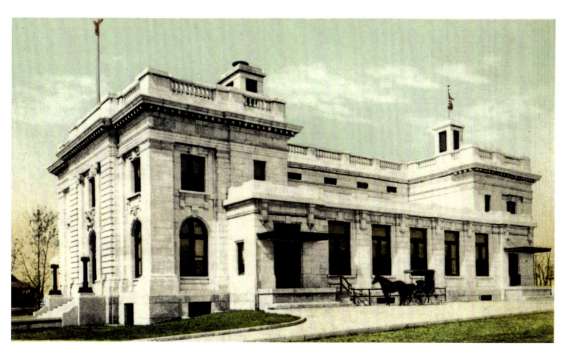

This undivided back, postally unused Detroit Publishing Company postcard dates to 1905, a year after the U.S. custom house and post office opened at West Avenue between Twenty-fifth and Twenty-sixth Streets. This image shows the service entrance to the building.

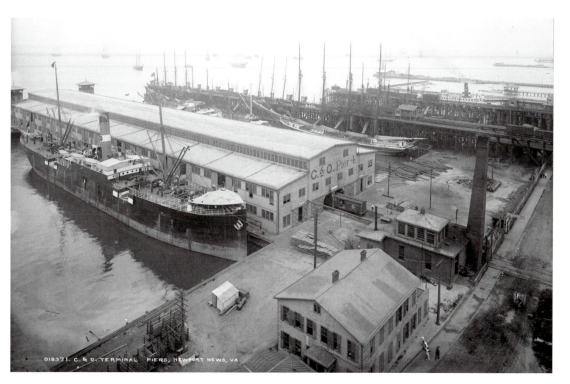

This is a northwesterly view of the Chesapeake and Ohio Railway's merchandise pier number four. In the foreground is the Chesapeake & Ohio's steamship *Kanawha* at the south berth and its sister ship at the north berth. There is a four-masted sailing ship at coal pier number three and the steamer *Virginia*, affectionately called "Smoky Joe," at pier number one. The picture was taken from the top of the grain elevator. *Detroit Publishing Company Collection, Library of Congress*

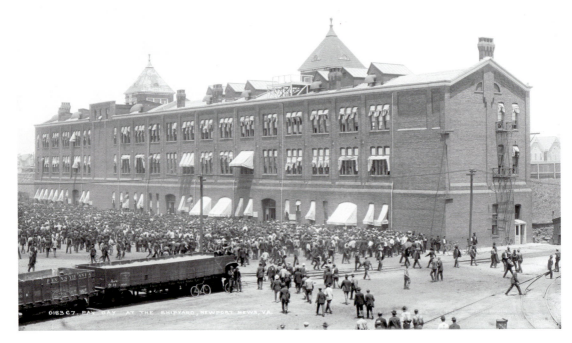

Pay day at Newport News Shipbuilding and Dry Dock Company was captured by a Detroit Publishing Company photographer in 1905. Shipyard workers went to the main office building (shown here) to collect their pay. The main office building, completed in 1890, was 200 feet by 40 feet. *Library of Congress*

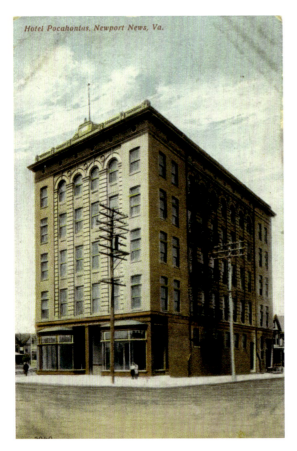

The Hotel Pocahontas (shown here) overlooked Newport News Shipbuilding and Dry Dock Company and Hampton Roads. Located at the corner of Thirty-fourth Street and Washington Avenue, it opened on July 15, 1904. The proprietors were brothers Charles Fletcher and Thomas Johnston Hundley, a real estate investor who eventually took over proprietorship of the Hotel Newport at 3005 Washington Avenue from his brother. Prior to taking over the Hotel Pocahontas, Charles Hundley had been a clerk at the Lexington Hotel.

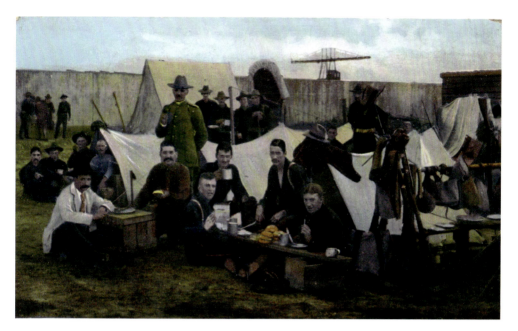

The second occupation of Cuba, also called the Cuban Pacification, was a major American military operation that started on September 29, 1906. After the collapse of Cuban president Tomás Estrada Palma's regime, President Theodore Roosevelt ordered an invasion of Cuba and established an occupation that would continue for nearly four years. A camp was quickly established at Newport News to serve as a base of operations. The postcard shown here, which dates to the period, shows an informal lunch being served in the camp. The October 11, 1906 *Mathews Journal* reported that two squadrons of the Fifteenth Cavalry and one battalion of the Twenty-eighth Infantry had just sailed for Cuba on the transport *Panama*.

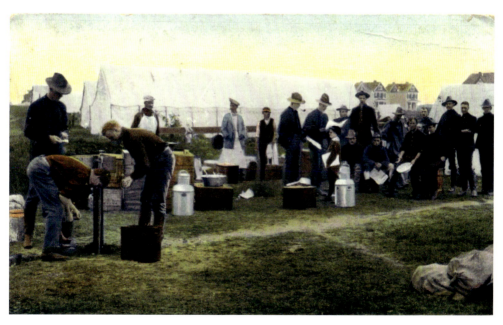

The goal of the Cuban Pacification operation was to prevent fighting between the Cubans, to protect North American economic interests, and to hold free elections. Following the election of José Miguel Gómez, in November 1908, Cuba was deemed stable enough to allow a withdrawal of American troops, which was completed in February 1909. Troops and supplies moved out of Newport News regularly and the embarkation camp, shown on this postcard image dating to 1906, provides a glimpse of what life was like for the troops who participated.

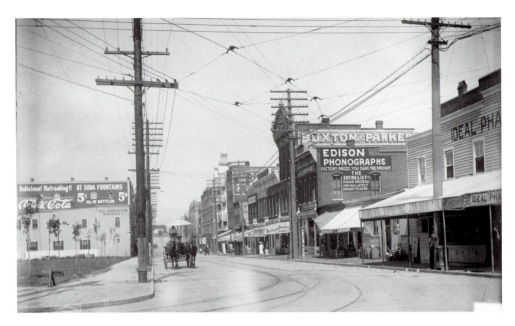

Twenty-eighth Street was a major business area of the city. This street crossed over Washington Avenue. Prominent in the middle of the picture is Buxton and Parker, a furniture store located at 212 Twenty-eighth Street. The photograph was taken by a Detroit Publishing Company photographer on a warm summer's day. Note the mix of horse-drawn delivery wagon and electric trolleys. *Library of Congress*

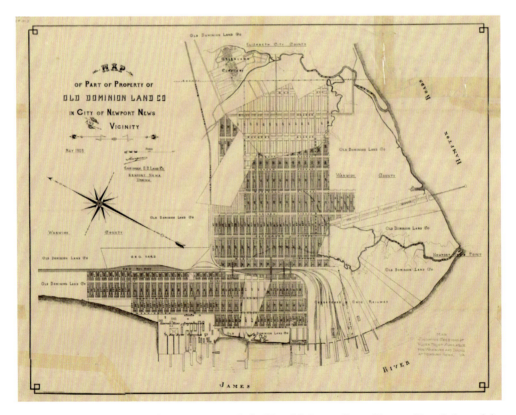

The area covered by this December 29, 1903 map is the Warwick County line to Newport News Point and the Elizabeth City County line to the James River waterfront. Landmarks include Newport News Shipbuilding and Pier A. *Martha Woodroof Hiden Memorial Collection, Newport News Public Library*

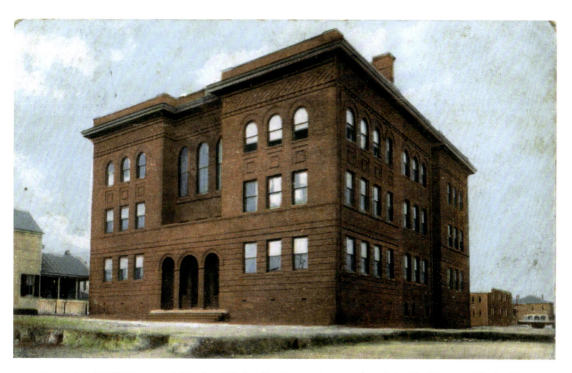

Located at 222 Thirty-second Street and facing Huntington Avenue, the original building on this site (shown on a 1907 postcard) was called the Central School, a grade and high school, built in 1899. In 1908 the school was renamed the John W. Daniel School after a United States senator of that name. The structure burned down in 1913 and was replaced the following year.

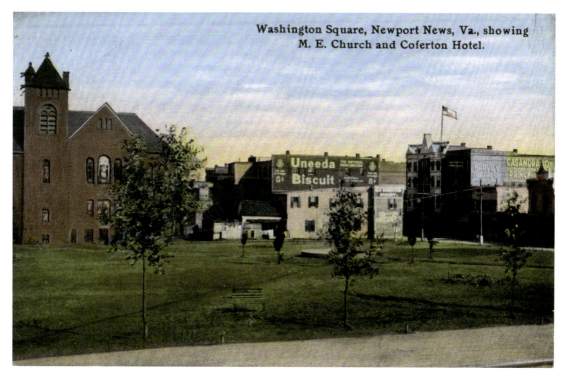

This image, which dates to 1907, depicts a scene from part of Washington Square. To the left is the Trinity United Methodist Church, and to the right on Twenty-eighth Street is the Coferton Hotel.

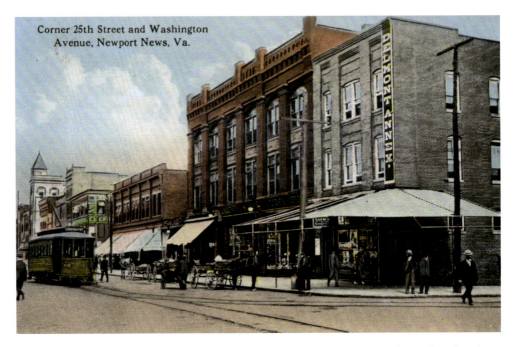

This postcard of the corner of Twenty-fifth Street and Washington Avenue has a bit of everything from horse drawn buggies and delivery wagons to the trolley. On the corner, at 2503 Washington Avenue, is the Delmont Hotel and Restaurant; the hotel provided furnished rooms and the eatery specialized in seafood. The hotel's proprietor was Daniel Welch, who with his brother Homer, had a restaurant at this location at the turn of the twentieth century under the name Welch Brothers; they also lived above the storefront.

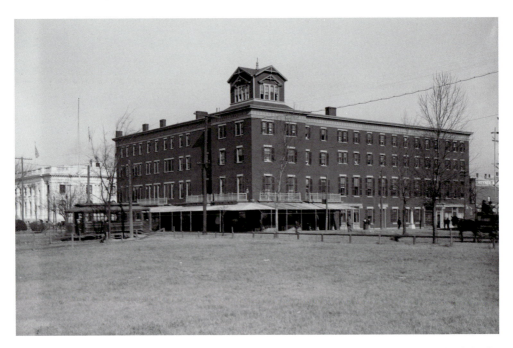

The Hotel Warwick, shown in this Detroit Publishing Company photograph taken in 1907, was built by the Old Dominion Land Company and opened on April 11, 1883. The hotel dominated the skyline physically but also as the driving force of community life in the salad days of Newport News; it was also home to Newport News' first bank and first newspaper, called *The Wedge*, published by Cassius M. Thomas. Warwick County government offices and the court were temporarily located in the building in 1888. *Library of Congress*

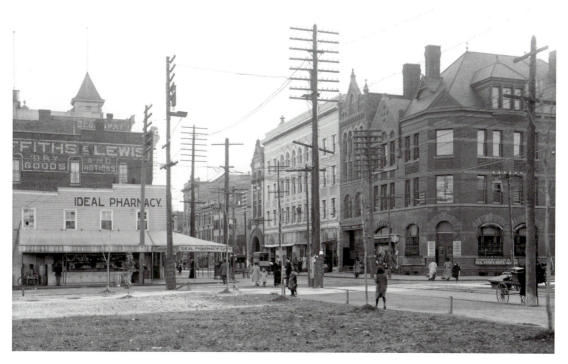

This Detroit Publishing Company photograph of the corner of Washington Avenue and Twenty-eighth Street, which dates to 1907, is looking south and shows two prominent businesses: Ideal Pharmacy (foreground, left) and First National bank (foreground, right). The First National Bank Building was constructed in 1892 on the southwest corner of this important Washington Avenue business corridor. When first built, the Old Dominion Land Company occupied the second floor but when this picture was taken, that floor, in part, was occupied by the law office of Allan Dudley Jones, who was last in this building in 1911 before the practice relocated. *Library of Congress*

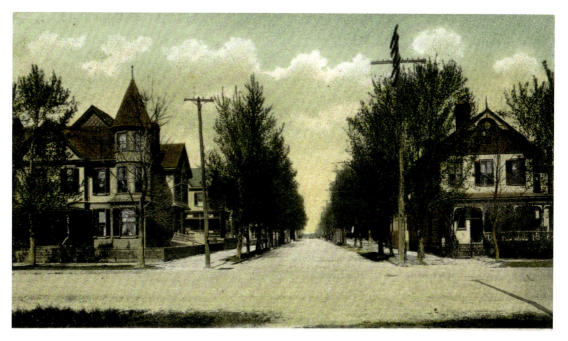

This is Twenty-eighth Street from West Avenue showing what was the city's premier residential section. The postcard postmark is 1907.

39

Starting in the 1880s Warwick Park (left of Twenty-fifth Street, center) and the Casino grounds (to the right), including the bowling alley right of the large casino structure center, were located on the banks of the James River between Twenty-fifth and Thirtieth Streets. The two parks served as the entertainment centers of the city, hosting everything from indoor and outdoor concerts, football games to first dates and wedding proposals. At the end of Twenty-fifth Street, far left, was a pier where steamboats brought passengers to and from Newport News. During World War I temporary buildings were constructed at Warwick Park. The park was downsized after the war and eventually fell out of favor with as newer parks and forms of entertainment replaced it.

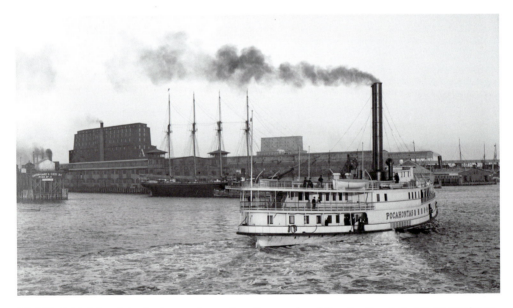

Of all Virginia's beloved riverboats, none is more happily remembered than the gleaming white SS *Pocahontas*, better known as "Pokey," which made three round trips weekly between Norfolk and Richmond on the James River. Along the way, it stopped at Newport News, Jamestown and a dozen or so plantation wharves that dot the shores of the historic counties of the Peninsula and Southside. Built in Wilmington, Delaware, in 1893 for the Virginia Navigation Company, this workhorse dubbed a "palace steamer" would run passengers, freight and livestock for twenty-seven years before it was sold off in 1920. The *Pocahontas* is shown in this photograph as it makes the turn into the Chesapeake & Ohio's Newport News berth at the end of Twenty-third Street. *Detroit Publishing Company Collection, Library of Congress*

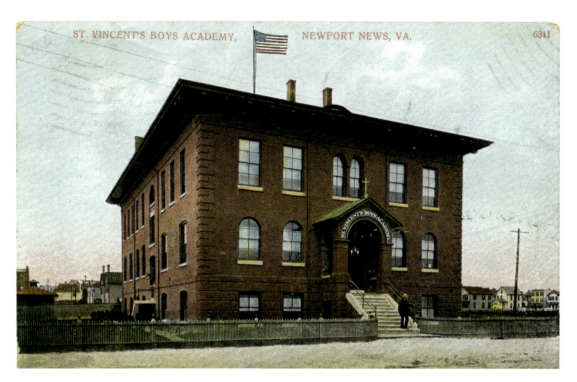

The Saint Vincent's Boys Academy was operated by the Congregation of the Mission of Vincentians; it opened its doors in 1902 at Thirty-fifth Street and Virginia Avenue.

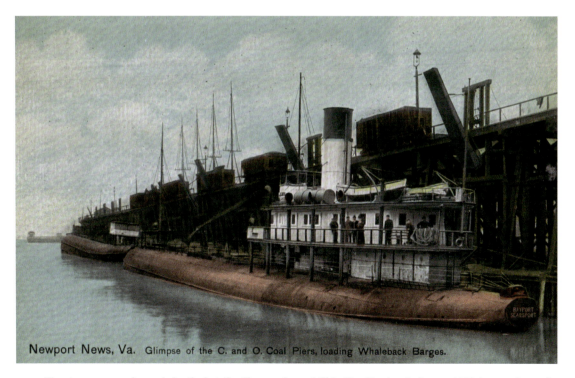

The steam powered vessels berthed at the Chesapeake and Ohio Pier Number 9, from a 1909 image, shows the whaleback steamer *Bayport-Searsport* (foreground) with a second whaleback barge taking on coal. These are ex-Great Lakes iron ore carriers put into coastal coal service. Whalebacks were small steel vessels about 260 feet long and two would easily fit on one side of the dock. A longer five-masted schooner is on the other side of the pier.

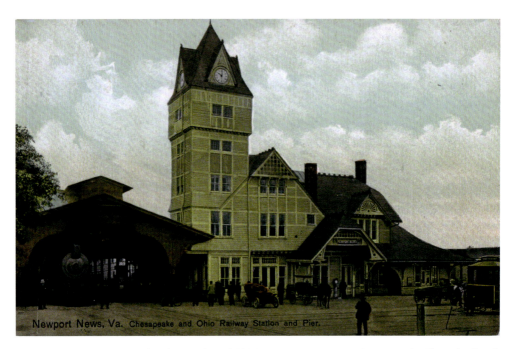

For nearly forty-eight years, the Chesapeake and Ohio's ornate passenger station was a significant landmark on Newport News's ever-changing waterfront. The depot opened on December 1, 1892, and remained functional until it was demolished in 1940. In the late 1940s, a new brick depot opened and operated until 1981. The postcard shown here dates to 1910.

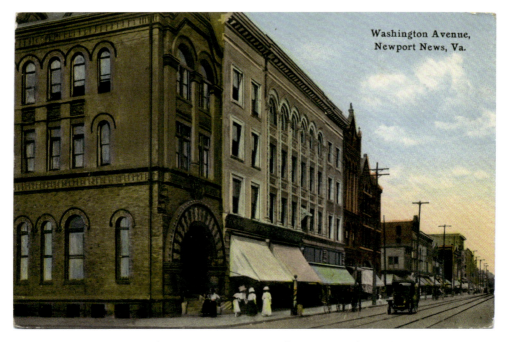

The Citizen's and Marine Bank (shown here, left foreground) was organized on July 28, 1891; its original location was 2813 Washington Avenue but it subsequently moved to the location shown here at the corner of Twenty-seventh Street and Washington Avenue. The bank's first president was George B. West. The F. W. Woolworth & Company 5 and 10 Cent Store occupied the ground level storefronts immediately next-door to the bank.

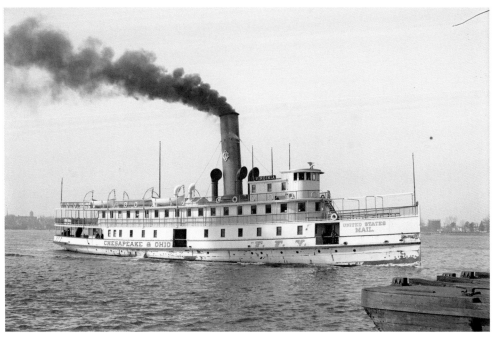

One of the most iconic steamers in Hampton Roads history is the *Virginia*, better known as "Smoky Joe." Between 1901 and 1949, this coal-fired vessel made three to four round trips a day between Newport News and Norfolk, its trips marked by a trail of thick, black smoke, the result of burning soft coal with high gaseous content and then sending it out through its hand-fired, natural draft boilers. The *Virginia* started out its thirteen-and-a-half-mile trip from Newport News' Twenty-third Street passenger terminal to Norfolk's Brooke Avenue. Built by Richmond shipbuilder William R. Trigg Company, the steamer was not named in honor of the Old Dominion but instead for Virginia Wilson Stevens, wife of the Chesapeake & Ohio Railway general manager and effective head at the turn of the twentieth century. *Detroit Publishing Company Collection, Library of Congress*

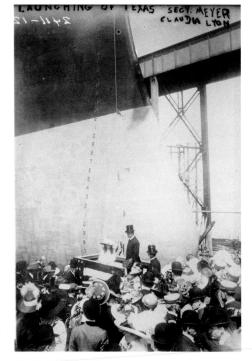

This Bain News Service photograph shows Secretary of the Navy George von Lengerke Meyer (1858–1918) with ship sponsor Miss Claudia Lyon, daughter of Texas Republican leader Cecil Lyon at the launching ceremony of the USS *Texas* (BB-35) on May 18, 1912, at Newport News Shipbuilding and Dry Dock Company. *Texas* was the second ship of the United States Navy named in honor of the state of Texas, and was a *New York*-class battleship. *Library of Congress*

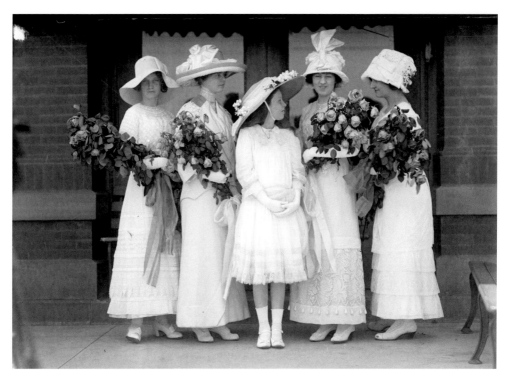

USS *Texas* (BB-35) sponsor Miss Claudia Lyon (center) is shown prior to the battleship's May 18, 1912 launch with her maids (left to right) Garland Bonner, May Colquitt, Ura Link, and Mae Furey. *Bain News Service Collection, Library of Congress*

Miss Claudia Lyon, flowers in one hand and the bottle of wine in the other, is about to christen the USS *Texas* before it slips down the ways on May 18, 1912. The "Big T" was struck from the navy record on April 30, 1948, and is today a museum ship at the San Jacinto Battleground State Historic Site. *Bain News Service Collection, Library of Congress*

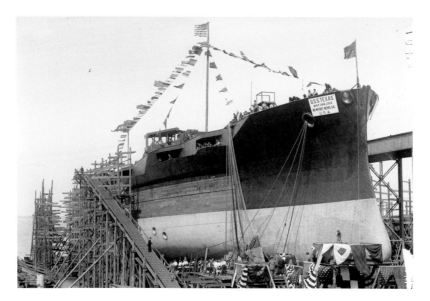

Among the world's remaining battleships, USS *Texas* is notable for being the only remaining World War I era dreadnought battleship, though she is not the oldest surviving battleship; *Mikasa*, a pre-dreadnought battleship ordered in 1898 by the Empire of Japan, is older than *Texas*. The "Big T" is also noteworthy for being one of only six remaining ships to have served in both twentieth century world wars. *Texas* is also the first American battleship to become a permanent museum ship, and the first battleship declared a United States National Historic Landmark. *Texas* is shown in this Harris & Ewing photograph as it sat in the ways, ready to be launched into the James River on May 18, 1912. *Library of Congress*

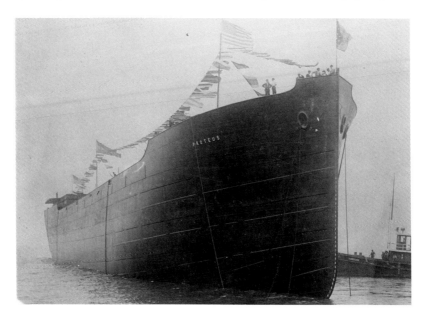

The collier USS *Proteus* (AC-9) was laid down on October 31, 1911, by the Newport News Shipbuilding and Dry Dock Company, and launched (shown here) on September 14, 1912. She was the lead ship of her class of four colliers. With the threat of war looming, she was commissioned on July 9, 1913, to the United States Navy, Master Robert J. Easton, Naval Auxiliary Service, in command. After extensive service to the navy, including Vera Cruz, the Philippines and World War I, *Proteus* was decommissioned at Norfolk on March 25, 1924, and remained inactive until its name was struck from the Naval Vessel Register on December 5, 1940. The ship was sold to the Canadian merchant navy and was lost at sea on November 23, 1941, highly likely due to a design flaw in *Proteus*'s collier class. *Bain News Service Collection, Library of Congress*

The Peninsula Electric Light and Power Company was established in 1891; it was located at 2701 Washington Avenue. Note the number of power lines attached to the building over the front door.

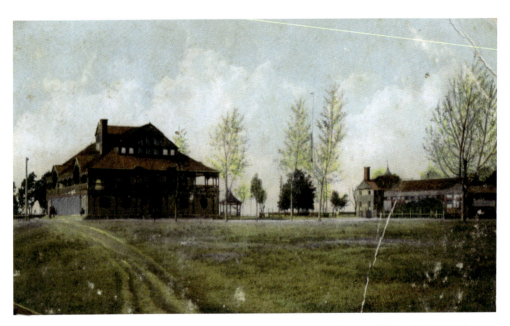

The Casino Park was located on the banks of the James River between Twenty-fifth and Thirtieth Streets. The casino building held balls and other forms of entertainment. There were bath houses and a bathing pier. Nearby was a bowling alley. The remnants of this park land extend from Twenty-sixth to Twenty-eighth Streets and is now called Christopher Newport Park. The building to the left is the casino building. The building to the right is the bowling alley. The pleasure pier fronting the James River was used for small boats. The casino grounds were once part of the Wilbern Farm, which was located on a bluff that overlooked the James River at what is roughly Twenty-seventh Street; the house survived until 1884.

This is a view of Twenty-fifth Street looking south to the Old Dominion Pier (also called Pier A) between Warwick Park (left) and Casino Park (right) in 1913. The pier, 900 feet long and 100 feet wide, handled both light merchandise and ferry passengers; note the trolley line down the center of the street.

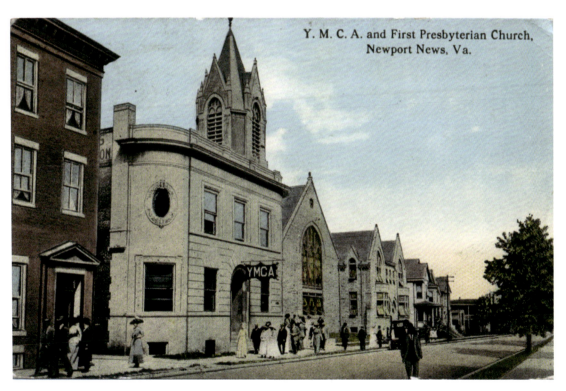

The Young Men's Christian Association (YMCA) and the First Presbyterian Church are shown in this 1914 postcard. The YMCA was located at 211-213 Thirty-second Street and the church on Thirty-second near Washington Avenue. First Presbyterian Church was established in 1883, its congregation first worshipping in a building called Union Chapel that once housed several denominations. Construction of the church shown here began in 1899, and the opening service was held there on October 7, 1900.

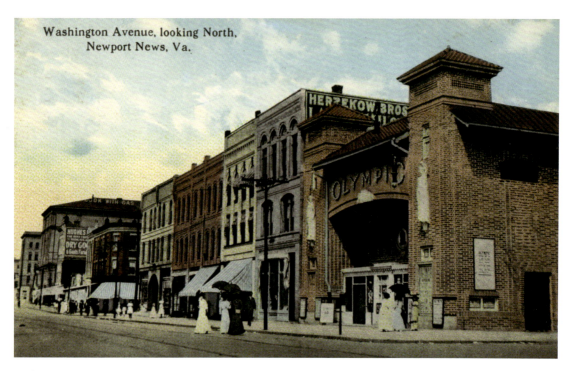

Looking north in the main business district of the city, in the foreground, is the Olympic Theater, which stood at the corner of Thirty-first Street and Washington Avenue. The theater was built in 1911. The postcard dates to 1914.

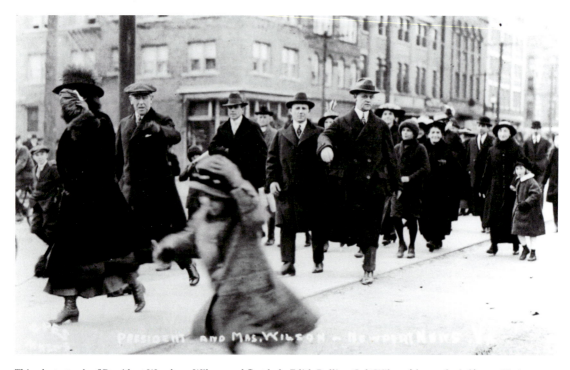

This photograph of President Woodrow Wilson and first lady Edith Bolling Galt Wilson (shown far left), was likely taken on February 12, 1916, and shows the president and his entourage walking toward Newport News Shipbuilding. Note the three United States Secret Service agents closely following the president. The president and first lady had earlier in the day strolled the grounds of Fort Monroe—an impromptu visit—just as much as his walk through the streets of nearby Newport News. *United States Naval History and Heritage Command*

II

THE HUNTINGTON ENTERPRISE FLOURISHES

Before World War I there were approximately 5,000 men on the Newport News Shipbuilding payroll and, even then, there were not enough homes for all of them. Despite a larger number of young men joining the United States Army and Navy, the shipyard rolls increased to over 7,500 by the time of America's declaration of war, with another 2,000 added by May 1917, a figure that would quickly go above 12,500. Coupled with the designation of Newport News as a major port of embarkation and establishment of army cantonments and warehouses in the vicinity, housing conditions were abysmal. Newport News Shipbuilding's management addressed the crisis as early as the summer of 1916 and launched a housing project of its own; twenty-two houses were built for black workers, followed by construction of a group of forty-eight homes for white employees on Virginia Avenue. These houses were sold to black and white workers at cost through a generous financial arrangement, and soon after war was declared other houses were acquired for ninety-two families. But construction could not keep pace with demand and temporary measures were taken, including tent colonies on the high ground north of Fifteenth Street for some shipyard workers' wives, and on the open ground between Forty-third and Forty-fifth Streets. The shipyard equipped each tent with a wooden floor and siding to give it some measure of comfort and privacy, and provided each with electric lights and a gas stove. Washing and bathing facilities were provided in separate structures, for joint use. Opposite the shipyard, on Thirty-ninth Street, a group of temporary barracks, providing dormitory quarters for 300 men, was erected. Behind these quarters were kitchen and mess hall arrangements for 500 men.

By the time the United States entered the war in Europe in the spring of 1917, Hampton Roads had become a gateway to oceangoing traffic. The piers and wharves of New York had been determined to be inadequate and already railways everywhere were overburdened. Newport News and Norfolk, on the south side, had eight trunk railway lines, an incredible harbor, and accessibility to coal and cotton. Commerce in the port, with war now reality, doubled and eventually quadrupled. Coal became the major export through the port; it was required for fuel in Europe. Trains brought it in vast quantities from the West Virginia fields, to be transferred to ships at Newport News, and Sewell's Point and Lambert's Point in Norfolk. While Collis Huntington was certainly attracted to Hampton Roads with what he believed were its warm waters, he might have been surprised that the James River froze over in the winter of 1917/18. Freight piled up on the piers and shipping was at a standstill. Even battleships, working as icebreakers, could make little headway through the frozen waters of Hampton Roads; the ice was that thick. The coal that awaited shipment in rail cars

froze and initially defied all efforts to load it onto ships until steam pipes were run through the cars to loosen the pieces, according to the historical record of this event. In addition to coal, petroleum products were also shipped from Newport News, as well as iron and steel, food stores and seafood, a major Hampton Roads industry.

The most important traffic to the port would be the troops and direct military supplies that went in an out of the region during the war. Norfolk, Portsmouth and Newport News shared the burdens and the benefits of this level of effort in support the United States military in time of conflict. Troops from across the country passed through the Virginia Peninsula, including what was then Warwick County, to the Newport News port of embarkation. Five United States Army camps were established, to include Camps Eustis, Morrison, Hill, Alexander and Stuart. Aviation and balloon schools, heavy artillery and infantry installations, facilities for all branches of training, and miles of barracks were established quickly. At Camp Eustis there was the only school of railway artillery in the world; it also served as a replacement training center for the coast artillery and, later, as a prisoner of war camp.

The advent of camps for the armed forces came with a unique set of community problems that would occur again during World War II. Newport News, previously an important embarkation point during the Spanish-American War, was selected by the British, French and Belgian governments as an embarkation depot two years before the United States entered World War I, and it was estimated that 457,000 horses and mules were brought to the Newport News waterfront from America's West and shipped to Europe for those governments. After the United States entered the war, 583 troop ships sailed from the embarkation port, carrying over 276,000 American troops, over 4 million tons of military supplies and more than 47,000 animals overseas. The Newport News community was in no position to accommodate the influx of this activity, physically or economically.

General Grote Hutcheson, military commander in the area, at a meeting of the Newport News city council urged that a road be built between Camps Stewart and Hill as an essential military measure. The new road, rushed to completion, played a major part in alleviating local transportation problems. The war further necessitated the enlargement of waterways and reservoirs to often three times their capacity; water had to be pumped from Harwood's Mill Pond into Lee Hall Reservoir at a rate of two million gallons a day and the federal government built reservoirs at Skiffe's Creek Reservoir and Harwood Mill as extra basins. The commonwealth of Virginia appointed forty members of the Huntington Rifles of Newport News to guard the reservoirs; they would be replaced later by a company of the Forty-eighth Infantry Regiment.

Women did their part for the war effort in a multitude of jobs previously held by men according to Newport News Shipbuilding's history. Fifty young women filed turbine blades back in 1918. For their accommodation the third story of the joiner shop was given a coat of white paint, electric fans and window shades with a "mirror or two" installed for good measure. Williamsburg native Mrs. Mityline "Mittie" Alice Goddin Daougherty (1876–1938), the first woman employee of Newport News Shipbuilding, was chosen as the "forelady." Daougherty had already served sixteen years in the tracing department of the shipyard when she assumed her new post.

On July 4, 1918, called "Liberty Launching Day," three *Wickes*-class destroyers were launched at Newport News Shipbuilding: the USS *Thomas* (DD-182), USS *Haraden* (DD-183) and USS *Abbot* (DD-184). At Newport News Point there was also established Southern Shipyard, which built and repaired all types and sizes of ships and remained in operation until 1934; it was placed in operation in November 1918, only days before the signing of

the armistice on November 11. After the war, Newport News's port of embarkation became a center for returning troops, who were cared for if wounded or sick, and also processed for separation out of the army. On April 13, 1919, the Victory Arch, spanning Twenty-fifth Street at West Avenue, was dedicated with much fanfare. This arch, built from funds raised by popular subscription in tribute to returning soldiers, over 440,000 of who passed through it on their return, bore the inscription from Robert G. Bickford: "Greetings with love to those who return—a triumph with tears to those who sleep." On August 22, 1919, Camp Stuart's hospital was closed and the final processing of returning troops took place at the port. Three days later, on August 25, Braxton-Perkins Post Number 25 of the American Legion was established at Newport News.

After World War I, there would be significant changes to Newport News' governance as well as its boundaries. On April 15, 1920, an area from Fifty-seventh to Sixty-fourth Streets was annexed because it had become solidly populated and was far removed from the other more densely inhabited parts of Warwick County. Effective January 1, 1921, the city moved eastward to Salter's Creek and its western branch, between Twentieth and Thirty-second Streets. Six months later came the addition of an area bounded on the north by the Hampton Branch Line of the Chesapeake and Ohio and extending eastward to the Elizabeth City County line. According to the October 21, 1999 *Daily Press*, in 1923, 79 residents of Kecoughtan petitioned circuit court, requesting that the town be annexed by Newport News. The issue was not without controversy, but two years later a three-judge court in Hampton approved the incorporation of Kecoughtan by Newport News and ordered that this become effective on the first day of 1927. Newport News didn't annex a similarly isolated part of Warwick County until December 5, 1950, a long stretch before the city again stretched its corporate limits. While it grew in size, Newport News also grew exponentially in the number of people who lived there. The 9,000 residents from 1896, the year of incorporation, had become just over 19,600 in 1900. Due to the port activity during World War I, Newport News had had slightly over 35,500 people living in the city boundaries by 1920; the population would hit a slight decline when the census of 1930 was recorded.

Newport News abandoned the bicameral form of city government and adopted a city manager-council form of government on September 1, 1920; the first mayor under this new arrangement was Philip W. Hiden, active in city and business affairs until his death in October 1936. Hiden founded the Hiden Storage and Forwarding Company in 1922 after he acquired twenty-five warehouses from the federal government, which offered them for sale after the war. The warehouses were juxtaposed near the Morrison Railroad Station, and Hiden's business was largely tobacco storage; his primary customer was the Tobacco Growers' Cooperative Association, made up of farmers from Virginia and the Carolinas, from 1923 to 1926 and individual farmers continued to use his facilities after the cooperative ended the contract. Hiden's enterprise was symbolic of the "new normal" in Newport News after the war. "Normal" returned and with it all manner of new businesses.

Along with new governance and business came another trend that continues today: suburbanization. Hilton Village, a planned, English village-style neighborhood located off the James River on 200 acres of land three miles north of Newport News' downtown in what was then Warwick County, was put up for sale by the United States Shipping Board in 1921; the Newport News Land Corporation was the purchaser. The story of Hilton Village is worth telling, in brief. Clearing for the village began on April 18, 1918, and the homes were built over the next three years. Hilton Village was developed in response to wartime housing shortages for Newport News Shipbuilding and Dry Dock Company workers during

World War I; it is recognized as the United States' first federal war housing project and was jointly sponsored by the shipping board and Newport News Shipbuilding. The village was built on the site of John Pembroke Jones's farm "Hilton" (originally named Milford). Hilton Village initially opened on July 7, 1918. The major architectural themes for homes in the project were Jacobethan, Dutch Colonial Revival, Tudor Revival and Colonial Revival. The village-style neighborhood was planned to offer many services locally, including plots for four churches, a library, a fire house, commercial spaces, and a school, Hilton Elementary School, completed in 1919. By the time of the Armistice on November 11, 1918, nearly 200 homes had been completed or nearly so and more than a dozen families had already moved into the development. The number of homes was scaled back to 473 after the war, and by the end of 1920, all of them had been completed and were occupied. After the homes came under private ownership, the Hilton Village community became a desirable suburban neighborhood, outside the old downtown area of the Newport News.

The end of the war found a shipyard and shipyard community ready to take on a highly anticipated naval expansion program. But then President Warren G. Harding convened the Washington Naval Conference for the limitation of armaments from November 12, 1921, to February 6, 1922. The resulting Washington Naval Treaty effectively ended current and future construction of a battleship fleet. Overnight $70 million of ship work came to full stop. Instructions came down from Washington to break up and scrap the three most powerful and largest naval vessels of their types in the world, the battle cruisers USS *Constellation* and USS *Ranger*, and the battleship USS *Iowa*, two of them almost ready for launch. This proposed "naval building holiday" of the world powers lasted fourteen years, ending in 1936 when Japan withdrew from the treaty. Newport News Shipbuilding looked to other industries to continue construction and repair work and, after careful study, turned to rebuilding locomotives, construction of freight cars and other products, all of which the yard stopped when the naval building holiday ended. While the yard could not build naval ships, it could work on civilian vessels. Notably during this time, it worked on the 60,000-ton SS *Leviathan*, and in doing so the yard took on the largest merchant ship reconditioning job then on record in the United States; this job alone provided a year's worth of work for 1,500 to 2,000 men. *Leviathan* came up the James River and slid into Pier 1 on April 10, 1922, for its $6 million overhaul. Another important and lasting venture for the yard was the building of hydraulic turbines, a field begun by the company in 1922 and in which it has become an industry leader. The giant hydroelectric plants at Muscle Shoals, Boulder Dam, Norris Dam, Grand Coulee Dam, and at Dnieprostroy in former Soviet Russia, just a few of more than sixty located in thirty-three different states and half-dozen countries in a period of just two years, all had turbines made by Newport News Shipbuilding.

While the Washington Naval Treaty led to an effective end to building new battleship fleets, some new ships were allowed with strict limits on size and armament. Newport News Shipbuilding was awarded contracts in 1927 to build the scout cruisers USS *Houston* (CA-30) and USS *Augusta* (CA-31) but a prescient writer in the *Shipyard Bulletin* suggested just then the way to go was "the airplane carrier." Soon after, the yard was actually engaged in the design and construction of the first carrier designed from the keel up: the USS *Ranger* (CV-4).

Lovers Retreat was a popular narrow beach at the end of Fifty-eighth Street on the James River. The postcard dates to 1915.

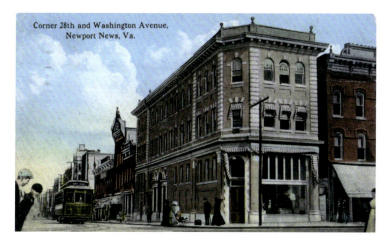

The corner of Twenty-eighth and Washington Avenue was the main business section of the city of Newport News. The building in the foreground is the Stearnes Building, specifically the Merchants-Mechanics Savings Association. At 212-214 Twenty-eighth Street, next to the trolley car, was located the Buxton & Parker Furniture Store.

The Elizabeth Buxton Hospital was founded by physician Joseph Thomas Buxton in 1906 and included a school of nursing. The postcard, which dates to 1915, shows the building located on the corner of what was then Boulevard and Cypress Avenues. The corner is now the intersection of Buxton and Chesapeake Avenues.

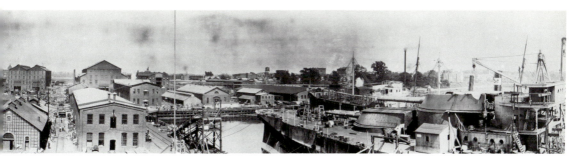

at that time exemplified the high standards of the founder, Collis Potter Huntington, whose statement, "We shall build good ships here at a profit if we can, at a loss if we must, but always good ships" is inscribed in bronze on a giant rock within the entrance. The photograph shows the steamers *Arlington* and *Brandon* in Dry Dock 1, the steamer *Maryland* in Dry Dock 2, and *Amalco* in Dry Dock 3. Hull 171, the battleship USS *Pennsylvania*, is at Pier 3, the collier *Walter D. Noyes* (Hull 189) at Pier 2, and the barge *Georgia* at Pier 6. *Library of Congress*

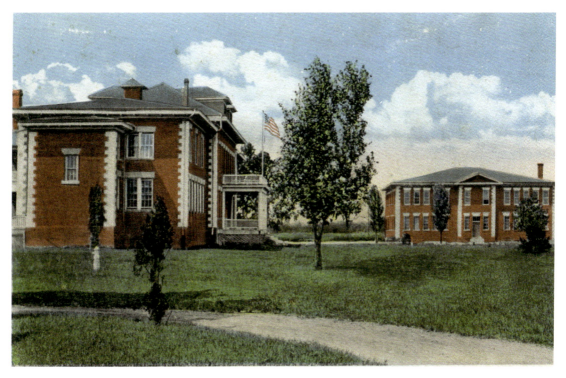

The Virginia State School for Colored Deaf and Blind Children was located at the northwest end of Pear (Sampson) Avenue and occupied a group of seven brick buildings (shown here, 1915) on its 140-acre spacious grounds, including a farm, workshops, and an infirmary. The school was founded in 1906 through the efforts of William C. Ritter, himself deaf, who was superintendent until 1937. Opened in 1908 with 25 children, the school, actually located in Hampton (not Newport News, as indicated by the postcard), had an enrollment of 100 in 1937 with nine instructors. Training was provided in farming, arts, crafts and trades, and in reading, writing and math; the school also had an orchestra. The school closed in 2008.

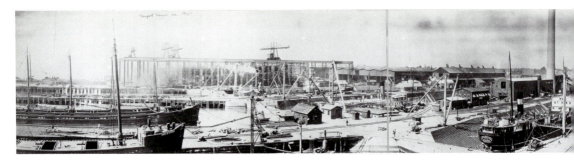

This September 6, 1915 waterfront view of Newport News Shipbuilding and Dry Dock Company plant was taken by a photographer from the J. P. Bell Company. The plant, open by arrangement, extends in this picture along Washington Avenue between Thirty-fifth and Forty-ninth Streets, stretching nearly a mile along the James River and covering 125 acres, and from its inception was an important factor in the development of Newport News. The vast plant of red brick shops was dominated by the numerous giant trellises of two steel cradles and three dry docks—one capable of accommodating the largest ships afloat. The clean and orderly appearance of the whole yard

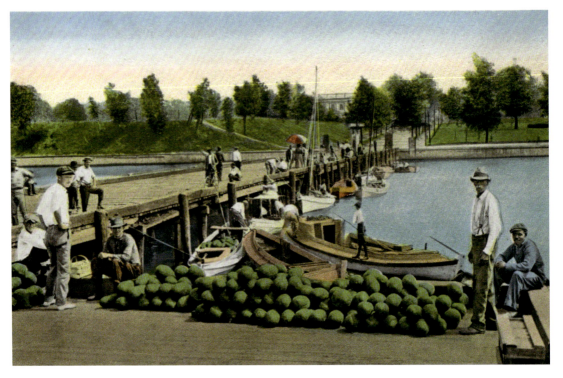

Produce boats lined Pier A offering watermelons and smoked meat from farms across the James River; a few of them are shown on this 1915 period postcard.

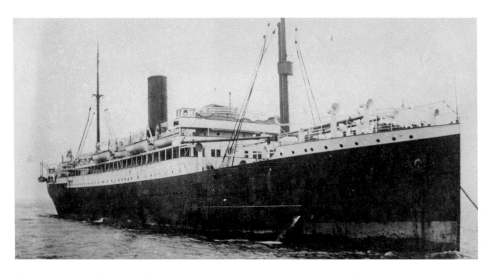

On the afternoon of January 15, 1916, 135 miles east by one-half north from Madeira, Portugal, the British steamship *Appam* was captured at sea by the German auxiliary cruiser Imperial German Navy raider *Möwe*. A prize crew was put aboard and she was taken to port at Newport News, Virginia. *Appam* was an English passenger liner built by Harland and Wolff at Belfast, Northern Ireland. The passenger liner was launched for the British and African Steamship Navigation Company, Liverpool, England on October 10, 1912, and operated by the Elder Dempster Line, Liverpool. *Bain News Service Collection, Library of Congress*

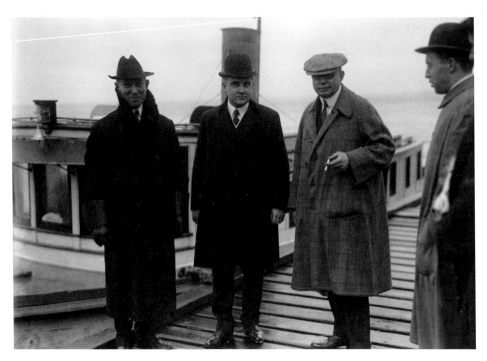

In the early morning hours of February 1, 1916, *Appam* sailed into Hampton Roads, Virginia, under command of German prize officer lieutenant Hans Berg. She had on board 451 people, made up of 155 crew members, 116 passengers, 20 German civilians, 138 rescued seamen, and the German prize crew of 22. The rescued seamen were from the seven British ships captured and sunk by *Möwe*. This Harris & Ewing photograph is of (left to right) Leopold Marshall von Schilling, vice consul of the German Empire; Norman Rond Hamilton, collector of the port of Newport News (later a Virginia congressman), and German prince Hermann von Hatzfeldt-Wildenburg (also the Duke of Trachenberg), chargé d'affaires of the German embassy in Washington, D.C. *Library of Congress*

Most of the *Appam* passengers were transferred to the New York bound Old Dominion liner *Jefferson* on February 3, 1916. On the seventh they sailed on the Holland-America liner *Noordam* for England. Shown here are Mrs. L. M. Riley and infant daughter Emilie, who boarded the *Appam* at Secconder and Lagos, Nigeria, in first cabin. *Bain News Service Collection, Library of Congress*

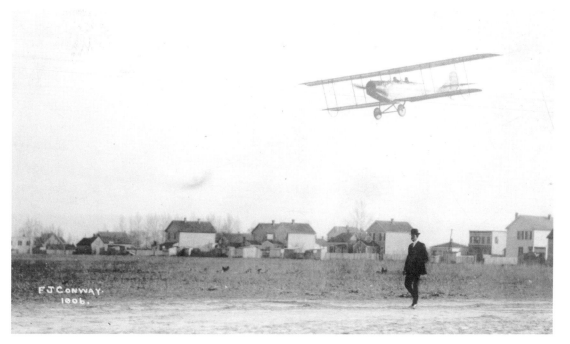

Glenn Hammond Curtiss's establishment of the Atlantic Coast Aeronautical Station at Newport News at the end of 1915, what many then called the aviation giant's southern experiment, was driven by climate and war. But it soon became as much about the people who came and went and the aircraft that came off the land and lifted from the water and into the history books. Curtiss's flying school and experimental station was all but gone by 1922, eclipsed by the new naval air station across Hampton Roads at Sewell's Point and the army's Langley Field in Hampton, both of which station manager Captain Thomas Scott Baldwin predicted would collocate with Curtiss's Newport News location as soon as it opened. This seldom mentioned Curtiss station was marked by great achievement and incredible tragedy. Frank J. Conway took this photograph of Curtiss on one of his rare 1916 visits to the station, a Curtiss JN-4D Jenny biplane soaring just overhead.

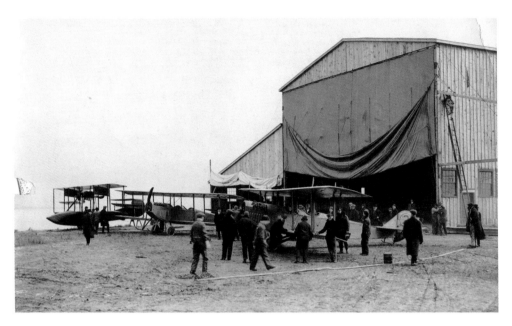

This is the first photograph that Frank J. Conway ever took of Curtiss's new flight school and experimental facility at Newport News. Curtiss Aeroplane Company instructor pilots, engineers and ground crew gathered around aircraft that had been rolled out of the station's main hangar on December 29, 1915. A Curtiss flying boat, called an F-boat, is on the left, its tail section resting on a sawhorse. The biplane in the middle is an early version Curtiss JN-2 Jenny, and the biplane in the foreground is a Curtiss JN-4D Jenny. The rear landing gear of the Jenny on the far right, in the foreground, is designed like a ski rather than the more common tail-dragger type.

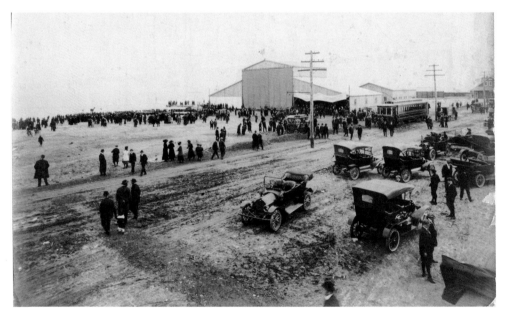

The Atlantic Coast Aeronautical Station was choked with curious onlookers almost every weekend. Anxious crowds watched Curtiss instructors, most of them also experienced test pilots, take off and land. The star attraction on the weekend Frank Conway took this picture was the Curtiss L-type triplane, visible just to the left of the large hangar building. While the L-type never saw action in World War I, it was prototyped for the United States Navy and had been aloft during limited test flights just before the war's end. Spectators from Norfolk and Portsmouth boarded the ferry in Norfolk and came ashore at the municipal small boat harbor. Visitors from farther away bought passage on steamers from Washington and Baltimore and other points north and south.

Newport News' municipal small boat harbor developed quickly after the arrival of Glenn H. Curtiss' Atlantic Coast Aeronautical Station, which included the Curtiss Flying School and a flight experimentation facility. The placid, recreational inlet shown here soon became home to aircraft and new industries, which developed along the road to the aviation field. This picture was taken by Curtiss Aeroplane and Motor Company photographer Frank J. Conway between 1915 and 1922.

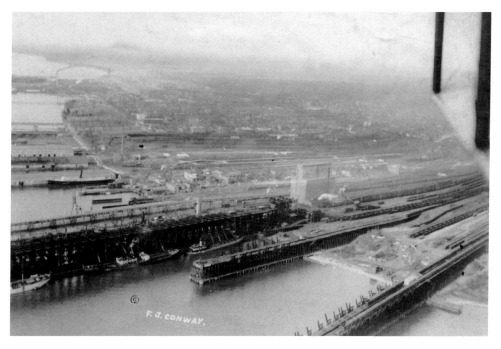

Frank J. Conway took this aerial photograph of the Chesapeake & Ohio Railway terminal in 1916, about five months after the fire that destroyed grain elevator A, the footprint of which is still visible in the foreground at the water's edge.

Vernon and Irene Castle, photographed on July 29, 1914, in a trademark ballroom dance pose, were all the rage in New York City, where they regularly performed. He was born William Vernon Blythe in Norwich, Norfolk, England, on May 2, 1887, and she was Irene Foote, born on April 17, 1893, in New Rochelle, New York. Beyond the trappings and exaggeration that accompanied his celebrity, Vernon Castle was a man of substance always in love with his wife. Castle, briefly an instructor pilot at Curtiss's Newport News flying school after completion of his own flight training there on February 5, 1916, was a man of grace, a trained civil engineer, and after he died two years later, those who had flown with him called Castle a damn good pilot. While at Newport News, Vernon and Irene Castle enjoyed the farewell dances and parties held often for men leaving for war; they are best remembered for exhibitions of the "Turkey Trot" and their famous "Castle Walk."
Library of Congress

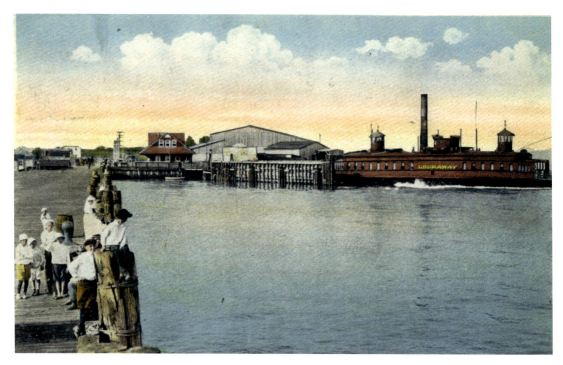

In 1913 the city dredged Newport News Creek into a municipal small boat harbor to accommodate the throngs of small craft on the waterfront. Fish- and crab-packing houses populated the shoreline. This small harbor served the city well until 1957 as the primary terminal of the Sewell's Point-Newport News ferry. The ferryboat *Rockaway* is shown (*right*) on this 1916 postcard. The large gray building (*center*) was a hangar belonging to the new Atlantic Coast Aeronautical Station.

This is the 1916 Newport News Shipbuilders baseball team, which played in the Virginia League. The Shipbuilders won the league championship in 1916 and 1917; the team's stadium was on Wickham Avenue in the east end of Newport News. Fred Payne (number 4 in the picture) played on the Detroit Tigers with Ty Cobb and Sam Crawford that won American League pennants in 1907 and 1908. Payne played two games in the 1907 World Series. Several of the ball players in this photograph played in the majors: Gardinier (Saint Louis Cardinals); Payne (Chicago White Sox and Detroit Tigers); Walker (Detroit Tigers, Philadelphia Athletics and New York Giants); Ray (Philadelphia Athletics), and Watt (Washington Senators). Team members (by the numbers): 1. Harry Lake; 2. Roy Gardinier; 3. Irvin Wratten; 4. Frederick Thomas "Fred" Payne (manager); 5. Wilson "Rusty" Walters; 6. Charles Frank Walker; 7. Arthur Smith; 8. John Voss; 9. Steve Gaston; 10. Carl Grady Ray; 11. Otto Pahlman; 12. Albert Bailey "Allie" Watt, and 13. Brook Crist (manager).

National guardsmen from fourteen states became the first noncivilian student pilots at the Atlantic Coast Aeronautical Station when they started flight instruction in April 1916. Standing in front of a Curtiss JN-4D two-seat trainer are (left to right) Second Lieutenant Bernard Cummings, of Colorado; Second Lieutenant Arthur Joseph Coyle, of New Hampshire; Second Lieutenant Edgar Wirt Bagnell, of Nebraska; Dr. Edward George Benson, of Albany, New York; and Second Lieutenant Bee Rife Osborne, of Kentucky. Benson was the "old man" in this picture at age thirty-seven. He died on November 22, 1928, from injuries sustained in an accidental fall. Osborne enlisted in the Kentucky National Guard on September 1, 1915, at age twenty-eight, and made second lieutenant in Company H of the Third Infantry of the Kentucky National Guard on July 6, 1916. He earned his reserve military aviator certification and his FAI pilot's license at the Signal Corps Aviation Station, Mineola, New York, that summer. Osborne transferred to active duty with the United States Army Air Service and served during the war in France, where he was eventually promoted to captain. After the war, he returned to Kentucky and became a ticket agent for the Chesapeake and Ohio Railway System. He died on December 22, 1968. Osborne is the first known Kentucky National Guard military aviator. *George Grantham Bain Collection, Library of Congress*

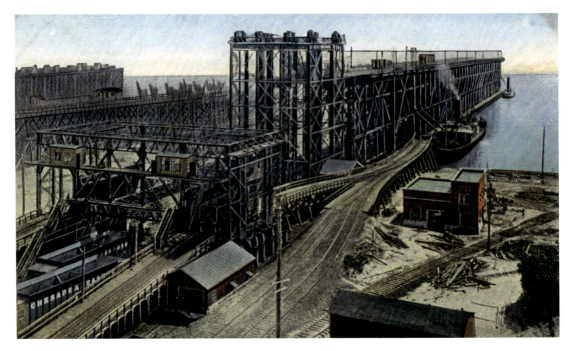

This postcard shows the new coal pier constructed in 1892. The high level coal pier was designed to overturn the coal cars for maximum performance in unloading their cargo. The Chesapeake and Ohio Railway linked the coal regions of the Appalachian Range with the Atlantic Seaboard. The postcard dates to 1917.

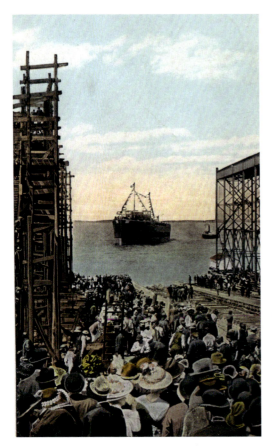

The Newport News Shipbuilding and Drydock Company was established by Collis P. Huntington on January 28, 1886, as the Chesapeake Dry Dock and Construction Company. During World War I the following ships were built for the U.S. Navy: the battleship USS *Mississippi*; the destroyers USS *Lamberton*, USS *Radford*, USS *Montgomery* and USS *Breese*; three large naval towing targets, and ten commercial vessels. The postcard shown here, which dates to 1917, shows the launching of a battleship from the shipyard.

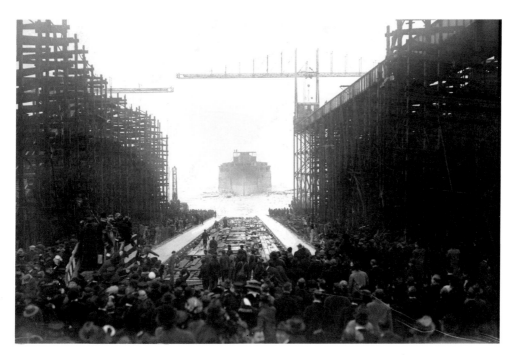

Newport News Shipbuilding and Dry Dock Company launched the USS *Mississippi* (BB-41) on January 25, 1917, and shown here. The *Mississippi* was a *New Mexico*-class battleship, the third ship of the United States Navy named in honor of the twentieth state, and the second battleship to carry the name. Commissioned on December 18, 1917, too late to serve in World War I, it served extensively in the Pacific in World War II, for which the ship earned eight battle stars. USS *Mississippi* was one of several pre-war battleships that participated in the Battle of Surigao Strait, the last battleship engagement in history. After the war, its two sister ships were quickly decommissioned and scrapped, but *Mississippi* continued to serve another decade as a weapons testing ship (AG-128); it played an important role in the development of the RIM-2 Terrier missile system. After an attempt to acquire it as a museum ship failed, the ship was sold for scrap in 1956. *Library of Congress*

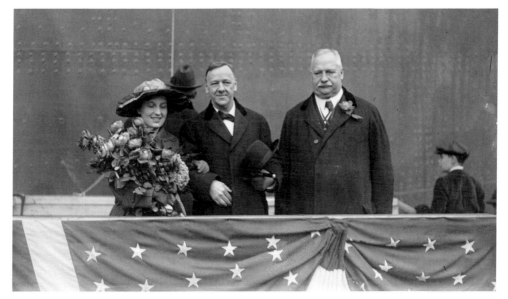

The USS *Mississippi* was sponsored by Miss Camille Sarepta McBeath, a Meridian native and daughter of the chairman of the Mississippi State Highway Commission James Marcus McBeath. She is shown in this January 25, 1917 Harris & Ewing photograph (left) with Secretary of the Navy Josephus Daniels (center). *Library of Congress*

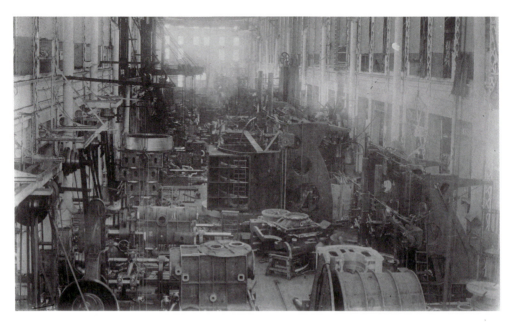

The interior of the machine shop at Newport News Shipbuilding and Dry Dock Company was photographed by a Bain News Service photographer in 1917. The original machine shop was 300 feet long but it was later length of 560 feet. The equipment stored in this space and shown in this photograph included a number of machined tools that, when installed, were beyond precedent in American tool building. *Library of Congress*

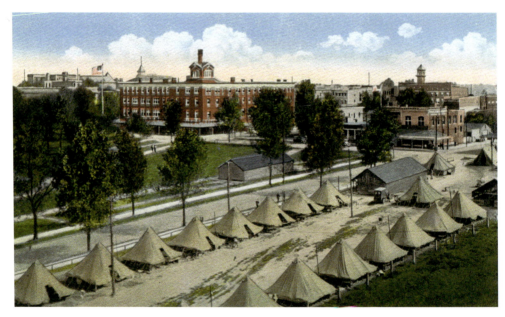

The United States Army cavalry camp shown on this 1918 period postcard was located on property adjacent to Newport News Shipbuilding and Dry Dock Company, specifically an area that would later become the yard's apprentice school athletic field. During World War I, it was a major port of embarkation for soldiers shipping out to Europe. Army camps were established throughout Newport News. The major camps were Camps Hill, Alexander and Stuart. The Hotel Warwick (in the background) was built by the Old Dominion Land Company as the city's largest residential structure and opened April 11, 1883. The hotel, which fronted West Avenue at Twenty-fourth Street, long served as the hub of city activities; it housed the county seat of government, the city's first bank and newspaper. Progressively modernized, a seven-story annex was joined to it in 1928. Fire destroyed the original hotel November 14, 1961, the annex surviving.

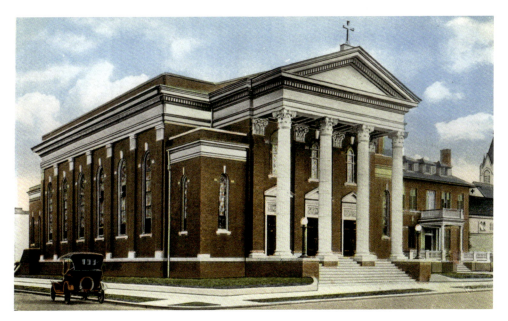

Saint Vincent de Paul Catholic Church (shown on this 1918 period postcard) was built between 1916 and 1917, in the Classical Revival style longitudinal-plan church; it was designed by architect Carl Ruehrmund (1855–1927). The front façade features a pedimented portico with four fluted Corinthian order columns. Associated with the church are the contributing rectory (1917 and visible to the right of the main sanctuary), garage (1917), and a prayer garden. The church fronts northwest on Thirty-third Street. The parish was first established as a mission of the Saint Mary's Star of the Sea Church at Old Point Comfort in 1881.

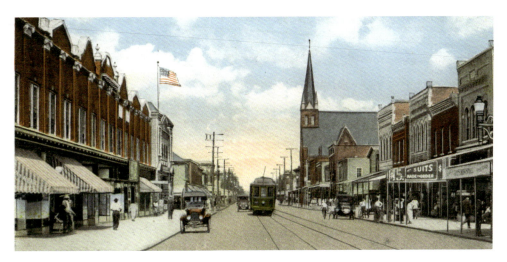

This is a view of Jefferson Avenue that dates to the World War I years from 1917 to 1918. The most prominent building on this period postcard is the First Church of Newport News Baptist (right). The church holds the distinction of being the first form of organized religion located within the original city limits of Newport News; in fact, it predates the city by 32 years, having been originally organized in 1864 as First Baptist Church by the Reverend Thomas Poole of Isle of Wight County. The small wood framed church located under what is now the Twenty-eighth Street Bridge was a spiritual home for many slaves, freed by the Emancipation Proclamation, whose only exposure to Christianity had come from their previous masters. The church moved to Twenty-third Street and Jefferson Avenue and continued to grow. In 1897, under Reverend William H. Dixon, planning and construction began on the new church building that would house the church for most of the twentieth century. The impressive structure would include a steeple that was believed to be the highest in Newport News and was a landmark on the city skyline for decades.

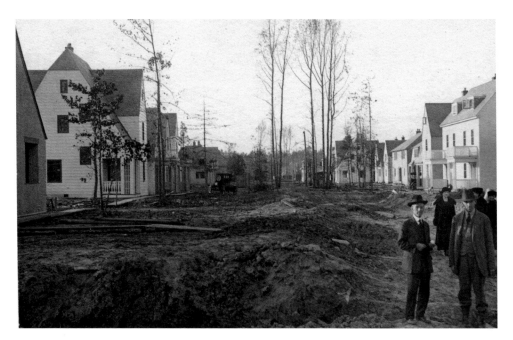

Hilton Village was still under construction in the fall of 1918 when this picture was taken. The street names in the 100-acre tract of former pine woods honor government and shipyard officials, including Post Road (shown here), named for Walter A. Post, a builder of the Chesapeake & Ohio Railway's terminals, first mayor of Newport News, president of the shipyard just before his death in 1912, and brother-in-law of Collis P. Huntington. The nearly 500 houses in the tract were sold to private owners after the war.

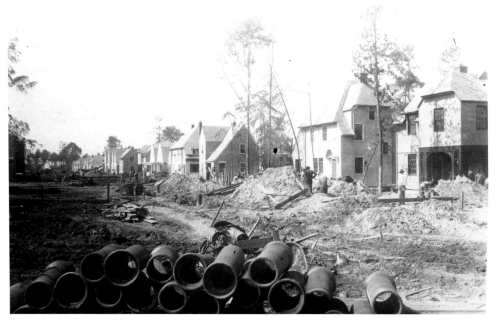

Hilton Village was designed by Harvard University landscape architect Henry Vincent Hubbard (1875–1947), hired as the project's town planner, and architect Francis V. Joannes (1876–1952), who modeled the homes on the English cottage style. Joannes was a late hire to the project, which had originally included Joseph D. Leland III as architect and Francis H. Bulot as sanitary engineer. Leland was unable to stay on the project. There were fourteen house plans developed for the landmark planned community, some of them visible in this fall 1918 photograph of the Post Road homes under construction.

The first streetcar to make the run from Newport News' downtown to the new Hilton Village housing development is shown in this image from September 1918. The streetcar belonged to the Newport News & Old Point Railway & Electric Company. The trolley barn and administrative offices for the company were at 3400 Victoria Boulevard (formerly Electric Avenue), the southeast corner of Victoria Boulevard and Algonquin Road in Hampton. Conductor Alvin Vernon Vann is seen far left; he became a bus operator after the streetcars ceased operation. Dignitaries on this historic trip included Homer Lenoir Ferguson and other shipyard, civic and military figures of the period. *Library of Congress*

Homer Lenoir Ferguson was elected president of the Newport News Shipbuilding and Dry Dock Company to succeed Albert Lloyd Hopkins, who lost his life when the RMS *Lusitania* was sunk by a German submarine on May 7, 1915. The Bain News Service photograph of him (shown here) is dated June 23, 1925. He was president of the shipyard from July 22, 1915, to July 31, 1946. As war clouds loomed over the United States in 1917, Ferguson had a major role in the development of Hilton Village, located just northwest of the shipyard. *Library of Congress*

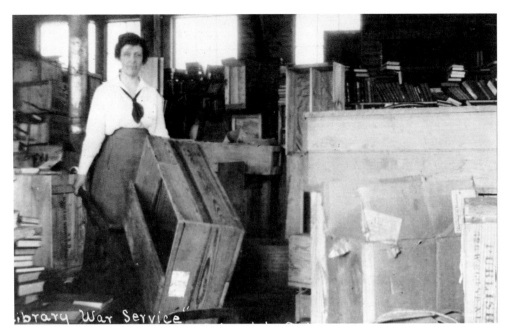

This seldom seen picture of a woman carting books at the American Library Association's Newport News dispatch office was taken in 1918. The dispatch office sent books out to various locations around the city to military camps, hospitals, army and navy clubs (included one set aside for black service members), embarkation headquarters, the Jewish Welfare Board, public health detention farm, quartermaster recreation house, Red Circle Club, Tidewater District YMCA, the local YMCA and also the YWCA. Harold T. Doughtery was the organization's local supervisor. *National Archives*

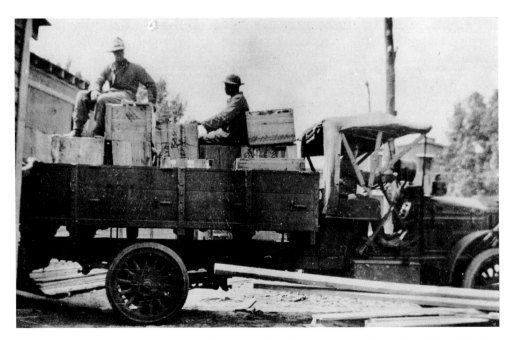

The American Library Association provided an unprecedented library war service during World War I. Once the books were loaded, they were trucked to aforementioned locations and into the hands of servicemen in makeshift and established libraries around the city and to outlying camps. The truck shown here making a delivery in 1918 was the typical method of moving reading material to the troops, such as the United States Shipping Board training school library at Camp Stuart. *National Archives*

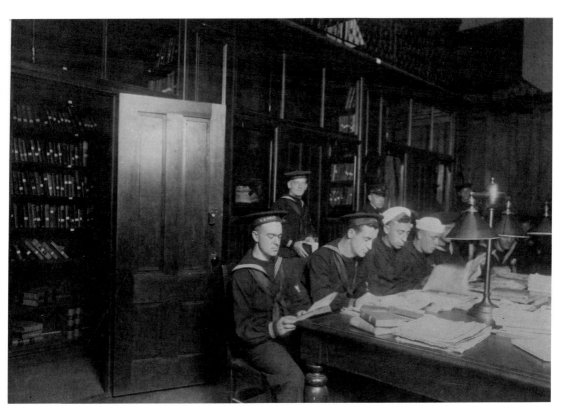

The American Library Association's Newport News operation provided a lending book service to military members at war and at home, dispatching books to locations such as the Knights of Columbus Hall at 226 Twenty-seventh Street (shown here, 1918). *National Archives*

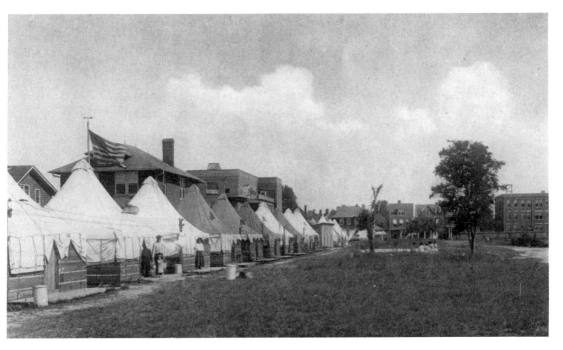

Some shipyard workers' wives lived in a tent colony north of Fifteenth Street during World War I; they are shown here gathered for a sociable afternoon in 1918. *Newport News Shipbuilding*

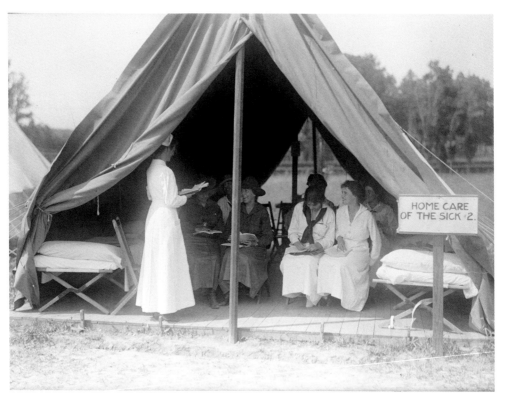

Here is a close-up of shipyard workers' wives and Red Cross volunteers in a tent in the colony north of Fifteenth Street in 1918. The sign next to the tent reads "Home Care for the Sick." *Library of Congress*

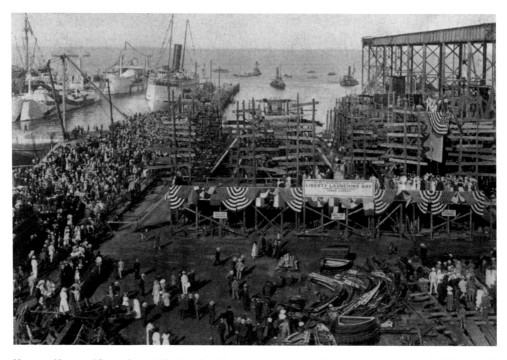

Newport News residents cheer at the launch of three destroyers on "Liberty Launching Day" on July 4, 1918, at Newport News Shipbuilding. These and eight sister ships built by the shipyard were among fifty destroyers transferred to Great Britain during World War II. *Newport News Shipbuilding*

Returning troop transports carried over 440,000 soldiers to Newport News at the end of World War I, greeted by bands playing patriotic period music as they marched up Twenty-fifth Street's "Victory Avenue" from the Old Dominion Pier (also called Pier A) and through the city's temporary structure of plaster and wood dubbed the Arch of Triumph but commonly called something less pretentious: the Victory Arch. The arch was dedicated on April 13, 1919. The soldiers shown here were among the tens of thousands of servicemen to return via Newport News; the Victory Arch is in the background.

The Chesapeake and Ohio Railroad, Newport News and Norfolk Terminal Division building, located at the corner of River Road and Twenty-second Street, is shown on this 1919 postcard. This is a westerly view of what was then the new division office and showing below-grade marble steps and the basement entrance.

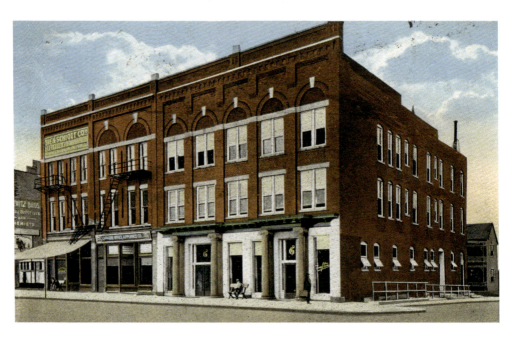

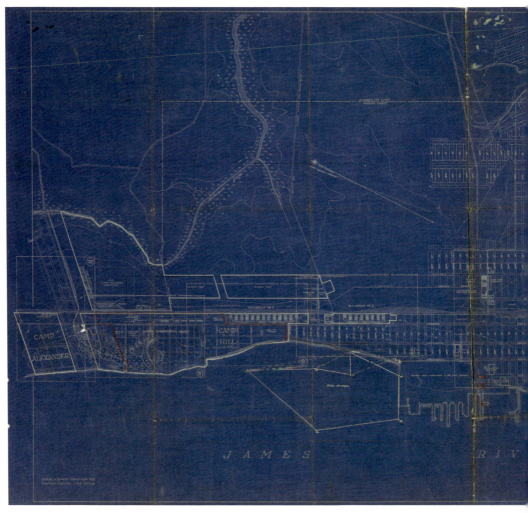

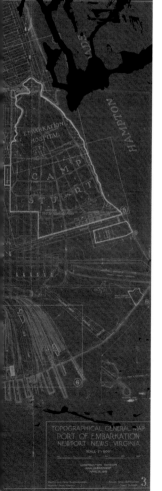

Above right: The Newport News Chapter of the American Red Cross moved from Washington Avenue and Thirty-second Street downtown to River Road and Twenty-fourth Street to be closer to the piers and the servicemen who needed their canteen and transportation services. Lelia P. Hudson was the canteen's hostess. The pictures shown here was taken in 1918. *National Archives*

Above left: The first reference to a hotel on the northeast corner of Washington Avenue and Twenty-fourth Street is the Hotel Grafton, which opened there in 1918; this postcard dates to the following year. When the building was razed in 1969, the last occupant was the Tidewater Hotel, which billed itself as "The Home of the Traveler."

Left: The blueprint shows the locations of World War I United States Army camps and buildings, including Camps Hill, Alexander and Stuart. Warehouse groups and administration and officers' quarters are also shown as well as the animal embarkation depot and embarkation hospital. The choice of Newport News as a port of embarkation was obviously made on account of its geographical location, sheltered roadstead, extensive rail and water connections, and open climate. The facilities for docking and coaling ships, loading troops, animals and supplies, and repairing and dry-docking vessels combined to make it the most logical port from which to conduct military embarkation and debarkation. Above all, the large areas of open country afforded building sites for the various camps and warehouses that were necessary for the men, animals, and supplies destined for overseas. *Martha Woodroof Hiden Memorial Collection, Newport News Public Library*

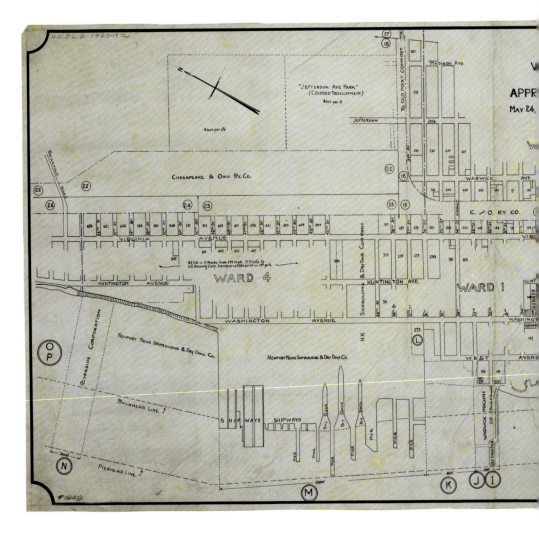

Above: The area covered in this Old Dominion Land Company map dated May 24, 1920, is from Fifty-ninth Street to Newport News Point and from east of Madison Avenue to the James River waterfront. The map includes the following properties: farm tracts, Riverside Corporation, lots given to the United States Housing Corporation, Jefferson Avenue Park (designated for the city's black community), Newport News Shipbuilding and Dry Dock Company, Warwick Machine Company, Old Finch Pier, Old Dominion Pier, Washington Park, Chesapeake & Ohio Grain Elevator Company, Pumpkin Hall Tract, Waterfront Lumber Company, Southern Shipbuilding Company, Dawson City, the municipal small boat harbor, and the municipal pier and ferry to Norfolk. *Martha Woodroof Hiden Memorial Collection, Newport News Public Library*

Right: This is Washington Avenue from Twenty-ninth Street looking north in 1920. Notable landmarks, starting left, foreground: the Broadway Store at 2905-2907 Washington Avenue; Epes Stationary Company (2908), which sold typewriters, adding machines, Kodaks and safes; Fergusson Music Company (2909-2911), Thomas H. Fergusson, proprietor, which sold pianos, including grands, uprights and players, Edison phonographs, records and sheet music, and the Hotel Newport, 3005 Washington Avenue, Henry B. Hite, proprietor. On the right, starting left, foreground: Sol Nachman's dry goods store (2915-2917), Solomon Nachman, proprietor, and Capital Dry Goods (2910-2912), specializing in ladies ready-to-wear.

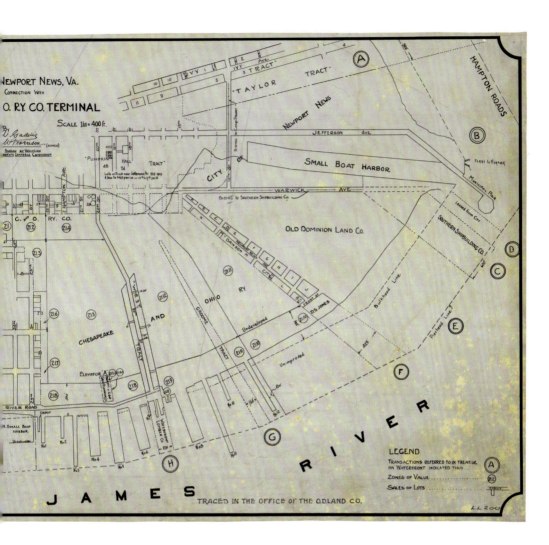

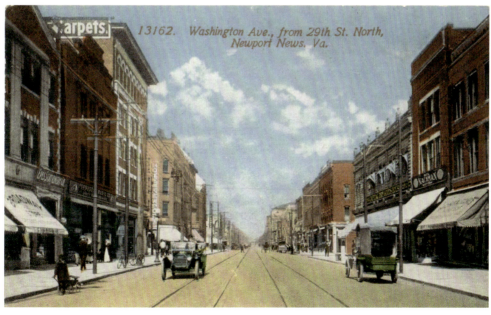

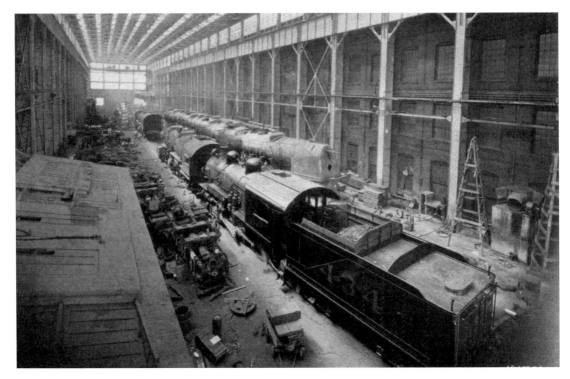

The erecting machine shop at Newport News Shipbuilding was used for a locomotive shop when this picture was taken in March 1923; 157 locomotives of many types were rebuilt there, from the rails up. *Newport News Shipbuilding*

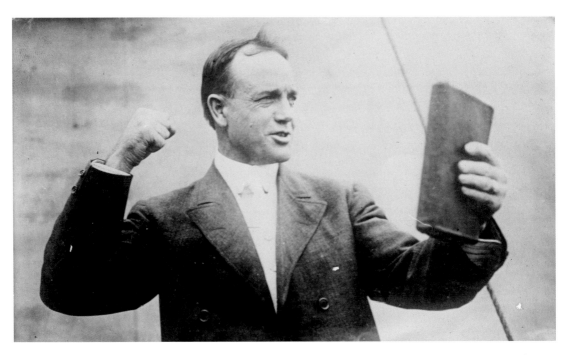

Famous evangelical Christian preacher William Ashley "Billy" Sunday (1862–1935) held a weeklong tented revival at Newport News's Casino Park that also included sermons delivered at Newport News Shipbuilding and Dry Dock Company, at the end of March, beginning of April 1925. Sunday, a former professional baseball player with good looks and a lot of charisma, drew thousands to the Casino grounds to hear him preach, despite the waning popularity of fire-and-brimstone preachers and revivals at that time. *Bain News Service Collection, Library of Congress*

The 1925 Newport News Apprentice School Builders football team is shown in this photograph. The team was managed by Edward J. Robeson Jr. (1890–1966), a civil engineer employed by Newport News Shipbuilding and Dry Dock Company from 1915 until his retirement in 1950 as a vice president and personnel manager. Robeson was the team's third head college football coach, a position he held for two seasons, from 1924 to 1925. From 1950–1959, Robeson was a United States congressman representing Virginia's first district. 1. William L. Glaze, assistant coach; 2. William Cumber, rubber; 3. Jerome A. Foretich; 4. Charles M. Rutter Jr.; 5. Edward P. Smith; 6. William Drummond; 7. Reginald Hansford; 8. John F. Darlington, trainer; 9. Romulus Raper; 10. George B. Helmer Jr.; 11. Gordon P. King; 12. Robert Morrison; 13. Albert W. Bainbridge; 14. Robeson, coach; 15. George H. G. Patterson, assistant coach; 16. Nathan Levy, graduate manager; 17. Ernest Bryan; 18. Charles A. Schmidt; 19. Edward Christiansen; 20. Russell S. Evans; 21. L. Earl Jones; 22. Anthony Frankie Jr.; 23. Edward B. Hanna; 24. Duncan C. Gimpel; 25. Charles E. Morris; 26. William Wallace; 27. John Clark Lincoln; 28. Allen G. Hogge; 29. Louis E. Keith, team captain; 30. Walter Lankford; 31. Samuel C. Rust; 32. William C. Shelton.

The Colony Inn, a latecomer to the Hilton Village planned community and originally incorporated in 1926 as part of ten four-room row houses (numbered 90-99 Main Street built on the north and south sides of the road), subsequently became one of two clubs on Main Street in the block just southwest of Warwick Boulevard, between the boulevard and Piez Avenue that opened in 1927; the Colony Inn was on the north side of the street at 90 Main Street, and the Village Inn, a restaurant, was on the south side. The Newport News Land Corporation built an officers' club on this site in 1918 for military personnel stationed on the Peninsula during World War I. That building, and a row of houses across the street became the Colony Inn. When first modified, the five connected houses on the south side of Main Street were extensively modified and expanded to accommodate the inn. Original plans called for an eight-story tower with a roof garden to the east (close to Warwick Road, later Boulevard); the addition was not done but guest rooms were added on the second and third floors of the tower of the original row house buildings. During World War II the Colony Inn was leased to the United States Army for use—again—as an officers' club and quarters for personnel assigned to the Hampton Roads Port of Embarkation.

The Colony Inn was remodeled from five four-room row house configuration—part of the original Hilton Village plan—to include a prominent two-story addition. Reportedly, some of the inn's furnishings came from the former German liner *Vaterland*, rebuilt for passenger service at Newport News Shipbuilding and Dry Dock Company in 1923, following duty as a troop transport during World War I. The inn served as a posh hotel after the addition, one that hosted President Herbert Hoover and first lady Eleanor Roosevelt when they attended ship events at Newport News Shipbuilding.

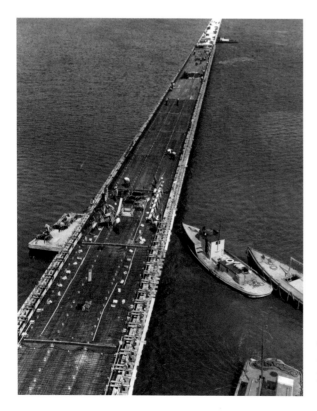

This Underwood & Underwood photograph was taken on November 8, 1928, of the James River Bridge at the end of construction; it opened nine days later to traffic.

III

A CITY IN DEPRESSION AND WAR

Newport News between the wars—and a depression—experienced highs and lows that would define it to the end of the twentieth century. Though there would be some population loss between 1920 and 1930 and during the Great Depression, by 1940, just prior to America's entry into World War II and with a reinvigorated shipbuilding program underway, the population of Newport News had risen to a number just over 37,000; it would take the remarkable events of World War II to move that number over 100,000, though it would level off to 50,000 within the city's boundaries after the war was over and wartime workers left the city.

Between the wars, after the October 1929 stock market crash, the city's economy took a downturn, a second—and terrible—blow after the Washington Naval Treaty put the brakes on $70 million in ship contracts at Newport News Shipbuilding. Jobs had already been lost at the shipyard in the wake of the disarmament agreement, and after the market crash unemployment and money troubles soon spread to the city's commercial corridors along Washington and Jefferson Avenues. Shops closed. Soup kitchens opened. Though the story of Newport News might appear to dim during the trying years of the depression, there were businesses that opened and employed hundreds of local people. Horace E. Dodge Jr., the car magnate and well-known powerboat racer, opened a division of the Horace E. Dodge Boat and Plane Corporation in the city in March 1930, attracted to the warmer waters of Hampton Roads. The plant employed 700 people working in three shifts to build powerboats like a car, in an assembly line. Though Horace Dodge Jr.'s Newport News plant closed in 1936, it reopened briefly during World War II to produce watercraft for the military before it shut down for good.

Camp Eustis, named for Brevet Brigadier General Abraham Eustis, the first commanding officer of Fort Monroe, and established in March 7, 1918, on Mulberry Island and surrounding land, was redesignated Fort Eustis on January 10, 1923, after which it continued as a training base, operated in coordination with Fort Monroe, and other property that had been taken up as wartime camps was reclaimed to private purpose. In 1925 Eustis National Forest was established on the installation. Much of the low lying land along the James River that now constitutes Fort Eustis was known in colonial times as Mulberry Island. The post was garrisoned by artillery and infantry units until 1931, when it became a federal prison, primarily for bootleggers during Prohibition. The repeal of Prohibition resulted in a prisoner decline and the post was taken over by various other military and non-military activities

including a Works Progress Administration (WPA) camp that utilized some of the barracks on the post during the Great Depression.

Not all was so grim for Newport News between the wars. Notably, today's Virginia War Museum was established in 1923 by American Legion Post Number 25—the Braxton/Perkins Post—as the American Legion Memorial Museum of Virginia. The city assumed administration of the museum in the 1950s, when it was renamed the War Memorial Museum. In 1987, the Virginia War Museum Foundation was established by the Newport News city council and the museum adopted its current name. Also established during this time was Huntington Park in 1924. The park, named for Henry Edwards Huntington, is located at the intersection of Warwick and Mercury Boulevards, nestled at the base of the James River Bridge. The park is also home to the Virginia War Museum, with displays of militaria from the Revolutionary War to the present. The city-owned waterworks system was completed in 1926, and the James River Bridge opened to traffic two years later. The $5.2 million privately-built bridge was opened on November 17, 1928, by the press of a button in Washington, D.C., where President Calvin Coolidge, sitting in the White House Oval Office, sent an electric signal to lower into place the upraised lift span over the James River channel. The Virginia State Highway Commission bought the James River Bridge system from the James River Bridge Corporation for $5.6 million on September 30, 1949. The bridge carries U.S. Route 17, U.S. 258, and State Route 32 across the river near its mouth at Hampton Roads; it connects Newport News on the Virginia Peninsula with Isle of Wight County on Southside Hampton Roads, and is the easternmost such crossing without a tunnel component. The four-and-a-half-mile structure was the longest bridge in the world over water when it was built. The original two-lane bridge was replaced from 1975 to 1982 with a wider four-lane bridge that could handle increased traffic volumes.

In 1930 Archer Milton Huntington (1870–1955), stepson of Collis P. Huntington, founded the Mariners' Museum, today one of the largest maritime museums in North America. Huntington and his wife, sculptress Anna Hyatt Huntington, acquired 800 acres of land that would eventually be occupied by 90,000 square feet of exhibition galleries, a research library (which moved in 2009 to the Trible Library on the campus of Christopher Newport University), 167-acre Lake Maury, a 550-acre park, and over 35,000 maritime artifacts from around the world, including the USS *Monitor* Center, where artifacts of the Civil War vessel, to include its innovative turret, engine and some personal effects of the crew that are conserved, studied and displayed. Lake Maury, named for nineteenth-century Virginia-born oceanographer commodore Matthew Fontaine Maury, was formed by damming the headwaters of Waters Creek, then corrupted to Watts Creek. The museum buildings were positioned in a rustic setting to house what was, even in the midst of the Great Depression, an impressive repository of maritime artifacts, collected from around the globe.

At Newport News Shipbuilding the writer who had so prophetically observed that the yard should be focused on ships that could carry aircraft "owing to the important part airplanes are to play in the warfare of the future," the USS *Ranger* (CV-4) was laid down on September 26, 1931, and launched on February 25, 1933, sponsored by Lou Henry Hoover, the wife of President of the United States Herbert Hoover, and commissioned at the Norfolk Navy Yard on June 4, 1934, with Captain Arthur L. Bristol in command. *Ranger* was the first ship of the United States Navy to be designed and built from the keel up as an aircraft carrier. *Ranger* was a relatively small ship, closer in size and displacement to the first American aircraft carrier—*Langley*—than later ships. Deemed too slow for use with the Pacific Fleet's carrier task forces, the ship would spend most of World War II in the Atlantic Ocean. The

Ranger was the first product of a new way of thinking. Successful aircraft flights across the Atlantic served notice to the United States Navy that ocean barriers had shrunk in defense importance. Thus, the shipyard modernized to develop more aircraft carriers and by 1933 was awarded hulls 359 and 360—the *Yorktown* (CV-5) and *Enterprise* (CV-6)—and with them won recognition as the nation's outstanding builder of flattops.

On the downside, pay and work hours at the shipyard were down, even after the yard adjusted rates, fees and hours to comply with the National Recovery Act. Only 32 hours per week were permitted on government work and a maximum of 40 hours on all other work. To compound hard times, the Chesapeake-Potomac hurricane, a category four, made landfall in northeastern North Carolina on August 23, 1933, with ninety-mile-hour sustained winds. The eye of the storm passed directly over Norfolk, the first time that had happened since 1821, and then moved north over the Virginia Peninsula. Along the Chesapeake Bay, the storm produced 100-year flooding from accompanying storm surge, setting records that remained for over 80 years. Damage to Newport News Shipbuilding and the surrounding community from this hurricane was extensive.

The *Ranger* portended, in large measure, what was to come. With the rise to power of Germany's Adolf Hitler in 1933, it became clear with the march of fascism over Europe that World War I had not been the "war to end all wars." Three years after Hitler christened the Third Reich, the United States Maritime Commission, under the auspices of the Merchant Marine Act of 1936, passed by Congress on June 29, 1936, replaced the United States Shipping Board which had existed since World War I; it was intended to formulate a merchant shipbuilding program to design and build five hundred modern merchant cargo ships to replace the World War I vintage vessels that comprised the bulk of the United States Merchant Marine, and to administer a subsidy system authorized by the act to offset the cost differential between building in the United States and operating ships under the American flag. The commission also formed the United States Maritime Service for the training of seagoing ships' officers to man the new fleet. Construction of the first fifty merchant ships began in 1936; these were ships that the commission could readily convert to warships if needed. The first contract went to Newport News Shipbuilding for the 723-foot ocean liner SS *America*, then the largest merchant ship ever built in the United States, completed April 16, 1940, for the United States Lines and designed by the noted naval architect William Francis Gibbs. *America* was acquired by the United States Navy on June 1, 1941, to be used as a troop transport and renamed USS *West Point* (AP-23); it was decommissioned from naval service on March 12, 1946, and returned to the United States Lines that year. *America* was eclipsed in 1952 by the larger and faster SS *United States*, one of the most extraordinary ships ever built by Newport News Shipbuilding.

During the crucial period between the wars, the army continued to train at Fort Eustis and the navy maintained a significant presence at the shipyard. Notable naval figures would be stationed at Newport News Shipbuilding, including Raymond Ames Spruance, who would later command United States naval forces during two of the most significant World War II naval battles in the Pacific theater: the Battle of Midway and the Battle of the Philippine Sea. Christening of the first *Yorktown* (CV-5) by first lady Eleanor Roosevelt on April 4, 1936, marked the fiftieth anniversary of the shipyard, which to that date had built some 325 notable ships. In 1939 Eleanor Roosevelt returned to Newport News to christen the aforementioned 35,000-ton SS *America*. In addition to battleships, aircraft carriers, cruisers, torpedo boat destroyers, submarines and gunboats, vessels built by the shipyard for the United States Navy also included tugs, ammunition lighters, oil barges, hospital ships,

colliers, oil tank ships, submarine tenders, monitors and floating targets. For the United States Coast Guard, the yard furnished a half-dozen cutters and a derelict destroyer, and for the United States Army Corps of Engineers, a cable layer and several suction dredges. Two fourteen-inch gun turrets, built for the army's ordnance department, were used in the defense of the Philippine Islands.

Newport News Shipbuilding was sold on May 10, 1940, to a consortium of seventeen investment companies. At the time of the sale, Archer Huntington controlled 74,000 shares and the estate of Henry Huntington owned 26,000 shares. A contract was received on July 3, 1940, for the USS *Essex* (CV-9), the first of one of the most famous aircraft carrier classes in history, and others followed. On January 17, 1941, the North Carolina Shipbuilding Company was organized to build merchant ships at Wilmington; Roger Williams was elected president and Homer L. Ferguson assumed the role of chairman of the board. The Wilmington yard launched its first ship on December 6, 1941, the day before the Japanese attack on Pearl Harbor.

The Newport News shipyard's history indicates that no job was too small and nothing was too large in the merchant ship arena; the yard built everything from lifeboats to the largest ocean liner ever constructed before the outbreak of World War II. Coastal and oceangoing passenger and cargo ships, river steamers, tankers, car floats, barges, palatial yachts, dump scows, ferryboats, tugs, and pilot boats were all built at Newport News Shipbuilding. With the launch of the *South Dakota*-class battleship USS *Indiana* (BB-58) on November 21, 1941, less than three weeks before the attack on Pearl Harbor, Newport News Shipbuilding would in the first two years of the war send no fewer than five cruisers and six aircraft carriers down the ways, in addition to eighteen tank-landing ships and four larger landing vessels.

Just as the United States entered the war, the shipyard had completed the first USS *Hornet* (CV-8) and was at work on other aircraft carriers to support the USSs *Ranger*, *Yorktown* and *Enterprise*. New carriers, apart from the *Essex*, included USS *Bonhomme Richard*, renamed *Yorktown* (CV-10) to replace its predecessor sunk at the Battle of Midway; and USS *Intrepid* (CV-11). Work also began on the second *Kearsarge*, renamed *Hornet* (CV-12) to replace the one sunk at the Battle of Santa Cruz Islands, and USS *Franklin* (CV-13), USS *Ticonderoga* (CV-14), USS *Randolph* (CV-15), and USS *Boxer* (CV-21). Not all the workers in Newport News at the start of the war had jobs at the shipyard though the yard was the largest employer, with a payroll that grew to 183,000 at the peak of World War II. The Hampton Roads port of embarkation was reestablished at Newport News; a troop shipment center was created at 1,700-acre Camp Patrick Henry in Warwick County, and Fort Eustis was expanded by the army, and would become a transportation center in 1946.

In the summer of 1943, the *Commonweal* carried a "Report from Newport News" in which architect Joseph Sanford Shanley described the impact of war, as he saw it, on the workers who had come to build ships and otherwise support the war effort in the surrounding community. He wrote about the two to five families that lived under one roof and about the sixty percent of young couples recently married and in many instances both husband and wife had a job. "Hours are long and work arduous," he would observe of the scene, "so that a flat really becomes just a shelter under which to lay a weary head. Beds are rarely made up, unwashed dishes and cutlery indicate haste, and over a sagging line strung from corner to corner, items of personal laundry dry in the breeze. Often a mother," he continued, "with one or more young children must live in these grim surroundings day after day." Most of those who came Newport News during the war were migratory workers whose disdain for their living conditions and surroundings was clear to Shanley, though the families had no energy

nor the heart to do anything to change either. While they complained, the pay was good but not enough to spend it fixing up temporary quarters. "Somehow," Shanley concluded, "these particular people did not seem to belong where they were. It is rather a case of a job having to be done, and of their being willing to put up with almost anything until it is accomplished," although he would also note that there were many brave young people who deserved greater praise for doing what amounted to the least glamorous role in the war effort.

Newport News saw tens of thousands of military men depart and arrive through the port of embarkation via the thousands of ships that came and went from the deep, churning waters of the James River. Interestingly, among the incoming passengers were just over 134,000 German and Italian prisoners of war, most of whom were quartered at a camp near the railway viaduct to the James River Bridge. Roughly five thousand prisoners were kept at Camp Patrick Henry; they were used to fill the critical labor shortage at the port of embarkation in 1944/45.

By the end of the war, Newport News Shipbuilding and all of those men and women doing the least glamorous work of the war effort had built forty-nine ships, and converted, refitted or repaired 1,497 vessels, including many for the United Kingdom. The United States Navy awarded the shipyard the coveted "E" pennant on February 2, 1942, and added five stars by war's end. No other shipbuilder in the nation delivered the diverse array of ships, in number, quality, best price and with the speed, of Newport News Shipbuilding and its North Carolina Shipbuilding division, which built 243 ships at Wilmington. After the Japanese surrender on September 2, 1945, peace and new opportunities came to the shipyard and to the surrounding Newport News community.

Called "North Enders," those who built homes on upper Huntington Avenue created the wealthiest residential area in the city, largely from the 1920s with some preexisting earlier homes. Houses faced the James River and today overlook where Newport News Shipbuilding builds nuclear-powered ships; this was the "Gold Coast of the James." The identifiable residences at Huntington Avenue at Sixtieth Street include (left to right) numbers 6014, completed in 1930 but still under construction when this postcard was printed in 1930; 6000, built in 1912 (an earlier North End home), and 5912, also built in 1930, complete in this picture. The postcard does not include 6008, which would soon rise between 6014 and 6000.

This is a 1950 period postcard view of the entrance to the Mariners' Museum with its larger-than-life statue of Leif Erikson (1938), a 12-foot replica of the Reykjavik statue by Alexander Stirling Calder presented to the United States by the Icelandic National League in the United States and also displayed at the World's Fair in New York in 1939, before being moved to Newport News.

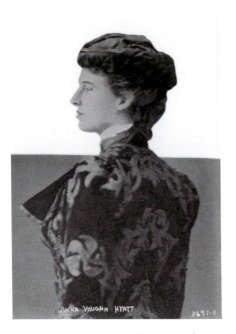

Above left: Anna Vaughn Hyatt Huntington (1876–1973) (shown here) was already among New York City's most prominent sculptors before her 1923 marriage to Archer Milton Huntington, Mariners' Museum founder. The photograph was taken between 1910 and 1915 by a Bain News Service photographer. Due to her husband's enormous wealth and the couple's shared interest in the arts and the outdoors, the Huntingtons were responsible for founding fourteen museums and four wildlife sanctuaries, among them, of course, the Mariners' Museum and the 550 acres of park around it. *Library of Congress*

Above right: "Conquering the Wild," a magnificent limestone statue by Anna Vaughn Hyatt Huntington and shown here as it looked in 1948, was installed at the Mariners' Museum as a memorial to Collis P. Huntington, founder of Newport News Shipbuilding and as the inscription on the base of the piece takes note: "Through his undertaking this museum and park became a possibility and a reality, 1930."

The true beginning of the armored force in the United States military was in 1928, twelve years before it was officially established, when Secretary of War Dwight F. Davis directed that a tank force be developed in the army, after observing maneuvers of the same in England by the British Experimental Armored Force. Secretary Davis's 1928 directive for the development of a tank force resulted in the assembly and encampment of an experimental mechanized force at Camp Meade, Maryland, from July 1 to September 20, 1928. The "tanks" shown crossing the James River Bridge on September 19, 1930, were called combat cars to avoid the use of the word tank as a legal formality after the National Defense Act of 1920 (the act that followed the Washington Naval Treaty, a disarmament measure following World War I) prohibited the development of tanks. Sixty-five military trucks, thirty of them carrying combat cars, were returning to Camp Meade from an exercise in Virginia Beach.

Situated on Mulberry Island in what was originally Warwick County, the Matthew Jones House illustrates the transition from the post-medieval vernacular to the Georgian style. The main body of the T-shaped house was probably built in 1727 for Matthew Jones, as suggested by an inscribed brick, although the large chimneys with divided stacks appear to survive from an earlier frame building; it is one of four colonial Virginia homes that incorporate a projecting entrance, which like its cruciform plan, exhibits post-medieval architectural traditions. The glazed-header Flemish bond brickwork is exceptional. The house is located on the south side of Virginia Route 60, on the Fort Eustis Military Reservation in Newport News and is the oldest building on the post. *Library of Congress*

Mathews Manor, was one of the seventeenth century sites excavated by Colonial Williamsburg's renowned archeologist Ivor Noël Hume during the 1960s; his findings revealed much about early domestic life in the Virginia colony. Mathews Manor was built about 1626 for Captain Samuel Mathews. The post-medieval Mathews Manor included a projecting porch and center chimney, both characteristic of Virginia's earliest substantial dwellings. The Mathews house burned in roughly 1650 and was replaced with a smaller house nearby, probably by his son, Samuel Mathews Jr., governor of Colonial Virginia (1656–1660). Referred to as Denbigh Plantation since the eighteenth century, this house is now also an archeological site. The remaining structures and foundations on the site are located on the south side of Virginia Route 60 in a neighborhood park in the Denbigh area of Newport News. Pictured is the milk house (also called the dairy), photographed in 1933. *Library of Congress*

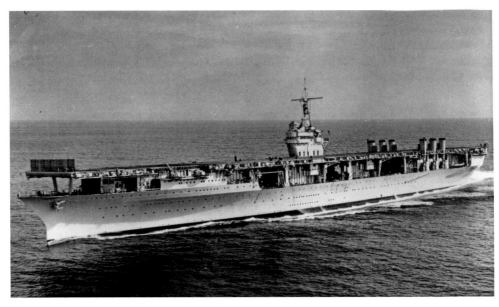

An island superstructure was not included in the original design of USS *Ranger* (CV-4), but was added after completion; the ship's six intakes (visible right in this 1934 photograph) were lowered during flight operations and it was the only ship with this feature.

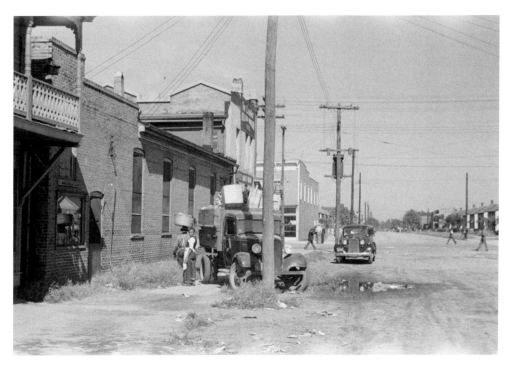

Paul Carter took this picture of the Jefferson Avenue section in September 1936, a time when many of the residents of this black Newport News community were preparing to move to the Newport News Homesteads. Referring to the 1920 map, Carter was looking down Twenty-first Street at the Jefferson Avenue intersection. The landmark is James Critzos's Leader Billiard Parlor, the tall building on the corner just beyond the truck loaded with a family's household goods; the pool hall was at 2117 Jefferson Avenue. *Farm Security Administration/Office of War Information Collection, Library of Congress*

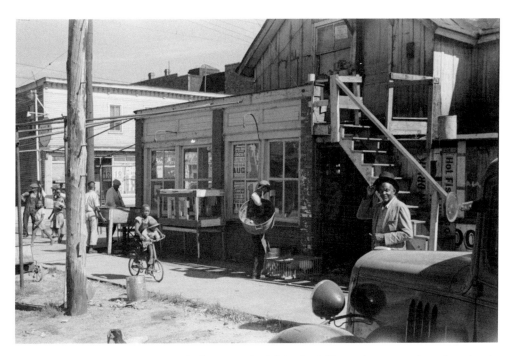

This is another Paul Carter view of black community life in the Jefferson Avenue section, also taken in September 1936. *Farm Security Administration/Office of War Information Collection, Library of Congress*

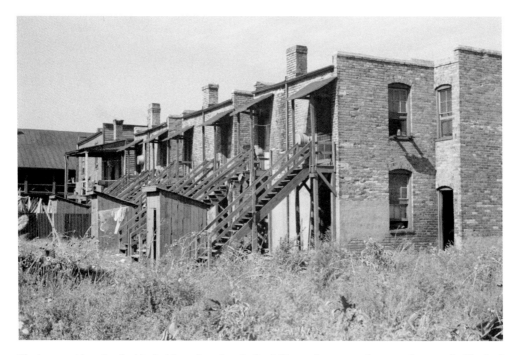

The tenement housing for black shipyard workers in the Jefferson Avenue section was photographed by Paul Carter, also in September 1936. The deplorable condition of these structures, from their lack of indoor plumbing to dilapidated appearance led to a New Deal housing intervention called the Newport News Homesteads. *Farm Security Administration/Office of War Information Collection, Library of Congress*

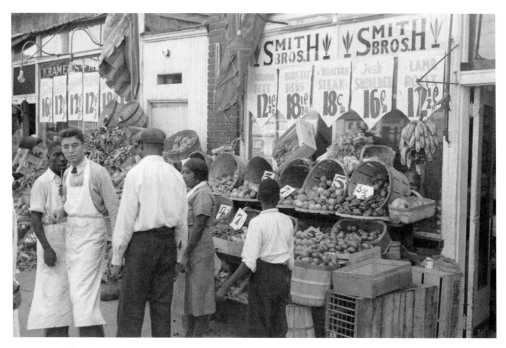

Kramer's Market (left) and Smith Brothers (right) are shown on a busy shopping day in September 1936. Kramer's was located at 2211 and Smith's at 2215 Jefferson Avenue in the heart of the city's black community. Kramer's was a meat market owned by Mike Louis and Daniel Kramer and Smith's was a grocery store run by Leon M. and Julius A. Smith; Paul Carter took the picture. *Farm Security Administration/Office of War Information Collection, Library of Congress*

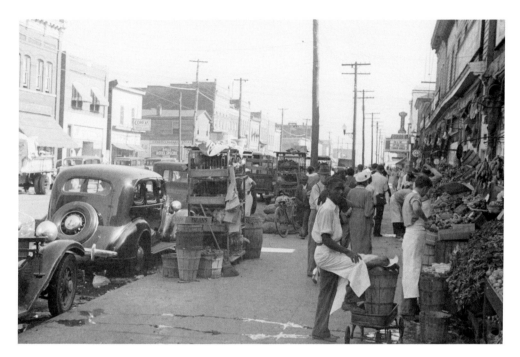

Here is another view of Jefferson Avenue looking down the 2200-block from in front of Kramer's Market and Smith Brothers. Mike and Daniel Kramer were ethnic Lithuanian merchants and among the many Russian and East European Jewish store owners who once populated Jefferson Avenue as well as the business section of downtown Newport News. Note the crates of live chickens lining the sidewalk on Kramer's side of the street. Beyond Kramer's is the Dixie Theatre at 2129-31 Jefferson Avenue. The picture is attributed to Paul Carter, and was also taken in September 1936. *Farm Security Administration/Office of War Information Collection, Library of Congress*

Paul Carter took this picture of fishing boats in the municipal small boat harbor in September 1936; there are a number of derelict boats visible, including one that has sunk. *Farm Security Administration/Office of War Information Collection, Library of Congress*

John Vachon (1914–1974) took this picture of the American Institute of Music and Dance in November 1937. The institute, with Mrs. Ethel Felice and Mr. Earl Brown, teachers, was located at 130 Twenty-fifth Street. *Farm Security Administration/Office of War Information Collection, Library of Congress*

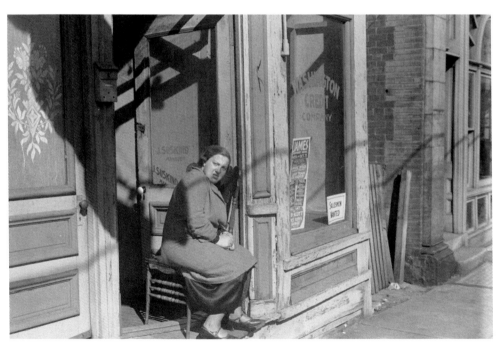

This unidentified woman was photographed by John Vachon as she sat in the doorway of the Washington Credit Company, Joseph Suskind, manager, in November 1937. The company was located at 3414 Washington Avenue. *Farm Security Administration/Office of War Information Collection, Library of Congress*

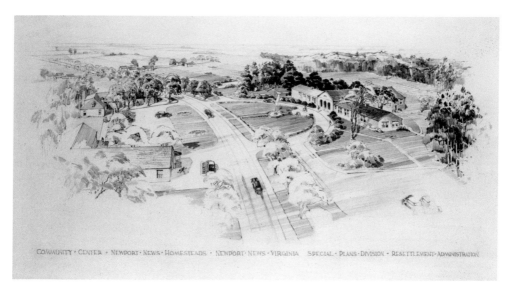

The United States Resettlement Administration/Farm Security Administration's Newport News Homesteads (later renamed Aberdeen Gardens) demonstrated community building "for blacks, by blacks" as the Great Depression took a financial and psychological toll on those who did not want a handout from the federal government but a way to earn a living and keep their self respect. Construction of the homesteads, started in 1934 and completed by 1937, were built for Newport News' and Hampton's black communities, and is situated in Hampton; the landmark is the intersection of Aberdeen and Newmarket Roads. This was the Resettlement Administration's only such project in Virginia and only the second neighborhood in the country for blacks financed by President Franklin Roosevelt's subsistence homestead project. An early drawing of the development is shown here. *Farm Security Administration/Office of War Information Collection, Library of Congress*

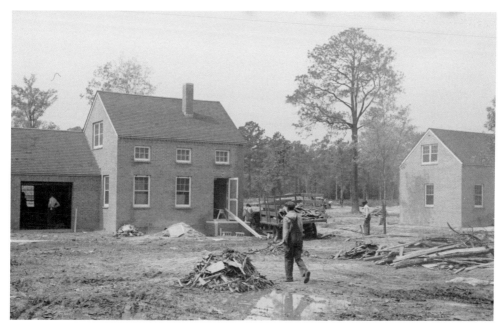

The Newport News Homesteads, renamed Aberdeen Gardens, became a unique 110-acre subdivision consisting of 158 single-family Colonial Revival homes set in an innovative open garden plan designed by black architect Hilyard R. Robinson and also built by black contractors and laborers. Paul Carter took this picture of black workers building the homesteads in September 1936. *Farm Security Administration/Office of War Information Collection, Library of Congress*

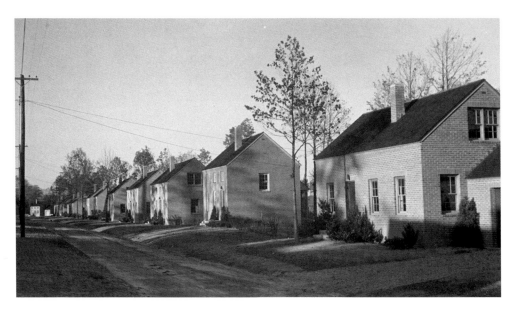

Aberdeen Gardens is composed of 158 brick houses on large garden lots, a school, and a community store, all within a greenbelt. The streets, excepting Aberdeen Road, are named for prominent African Americans. A Street, for example, became Lewis Road, named for Matt N. Lewis, pioneer black journalist for the *Newport News Star*. Aberdeen Gardens offered home ownership and an improved quality of life in a rural setting; half the homes were finished by the end of 1936. John Vachon took this picture of newly completed row homes in October 1937. *Farm Security Administration/Office of War Information Collection, Library of Congress*

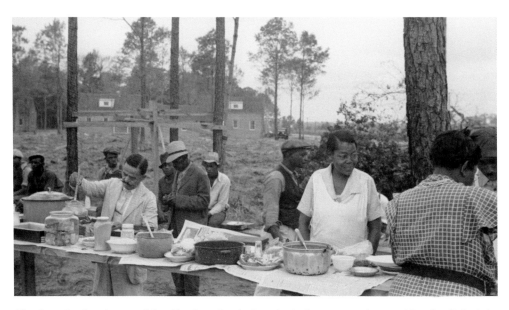

Aberdeen Gardens is named for Aberdeen Road, the principal transportation corridor that linked the worker-residents with Newport News and its shipbuilding facilities. The 440-acre project area of forest and farmland near Aberdeen Road, between Hampton and Newport News, was built on property acquired from the Old Dominion Land Company, John G. Curtis, who had a farm that would make up the southern part, and the Todd family, including Elijah, L. B., Henrietta and Ella, whose farmland comprised the northern part, respectively, of the development. The Todd farmhouse, built in the 1890s, was retained in the project and occupied by a large homestead family—the Johnsons—who sold produce locally. Paul Carter took this picture of a picnic on the land during the construction of the homesteads in September 1936. *Farm Security Administration/Office of War Information Collection, Library of Congress*

John Vachon photographed this young couple moving into the Newport News Homesteads, renamed Aberdeen Gardens, in November 1937. Aberdeen Gardens offered brick houses, large garden lots, a school and community store, all within a greenbelt. Most importantly, if proffered home ownership and an improved quality of life in a rural setting. In 1994 this nationally significant neighborhood was listed as a Virginia landmark and in the National Register of Historic Places, through the efforts of former and current residents. *Farm Security Administration/Office of War Information Collection, Library of Congress*

The Colony Inn, with changes to the frontage and signage, is shown on this 1939 linen postcard. The inn was taken over during World War II by the military to support multiple activities associated with the Hampton Roads port of embarkation. For three-and-a-half years, the inn was leased to the United States Army; it did not reopen as an inn until May 3, 1946. The story of the Colony Inn was short-lived after the war; the Bank of Warwick razed the first part of the inn in July 1955 and much of the rest came down in sections in the years to come.

Above: Jazz legend Ella Fitzgerald was born in Newport News's Jefferson Avenue section on April 25, 1917; she was called "The First Lady of Song," an honor whose meaning is captured in a compliment paid to her by the great composer Ira Gershwin: "I never knew how good our songs were until I heard Ella Fitzgerald sing them." She is shown here in a Carl Van Vechten gelatin silver portrait that dates to January 19, 1940. *Library of Congress*

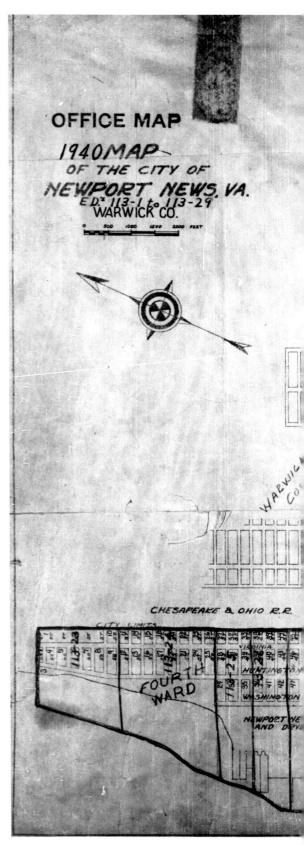

Right: This is a 1940 map of the city of Newport News and its boundary with Warwick County. The highlight of this map is the 100-acre Horace E. Dodge Jr. (1900–1963) property just east of the municipal small boat harbor, where Dodge would build powerboats; the land is located near the small boat harbor between Ivy Avenue and Salter's Creek near Newport News Point and was previously occupied by Camp Stuart during World War I. *National Archives.*

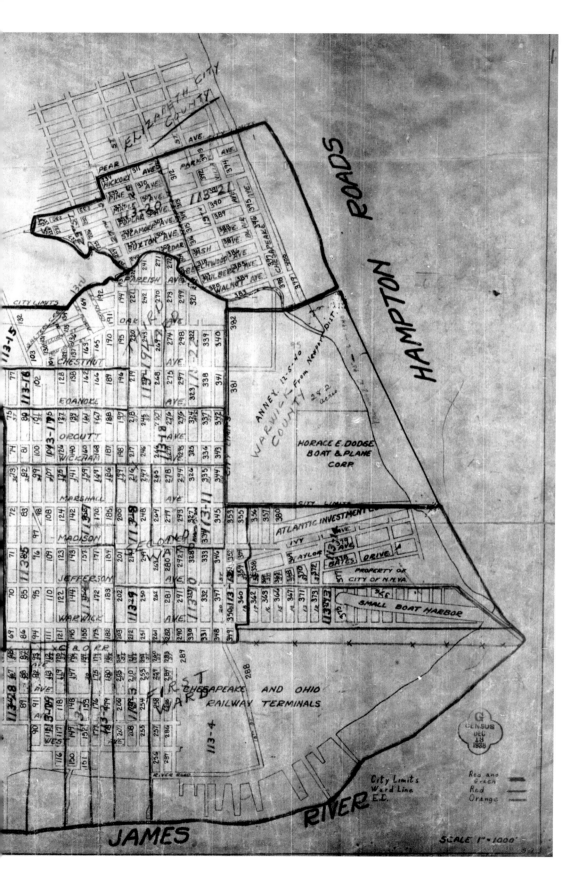

In early 1924 Horace Dodge Jr. produced the first "Dodge Water Car." By 1930 Dodge Boat Works was known as the Horace E. Dodge Boat and Plane Corporation and was just then located at the larger facility in Newport News, although Horace still owned facilities in Detroit. This period Dodge Boats advertisement shows the layout of the Newport News powerboat manufacturing facilities.

The Horace E. Dodge Boat and Plane Corporation property was "still on the map" in 1940 despite the fact the plant closed in early 1936 due to deepening hard times of the Great Depression. This vintage advertisement dates to 1930 and promotes the plant in Newport News.

Right: Horace E. Dodge Jr. is shown here in a December 17, 1928 press photograph with his wife, the former Lois Virginia Knowlson, aboard the Cunard RMS *Aquitania*.

Below: Annie Reid Knox, wife of Secretary of the Navy Frank Knox (shown here), prepares to christen the navy's aircraft carrier USS *Hornet* (CV-8) on December 14, 1940, at Newport News Shipbuilding as her husband looks on. On October 26, 1942, during the first year of World War II in the Pacific, the *Hornet* was heavily damaged during the Battle of Santa Cruz Islands when it was struck by six bombs, four torpedoes and two suicide aircraft. The following day in the early morning hours the carrier sunk after being hit by four torpedoes from two Japanese destroyers.

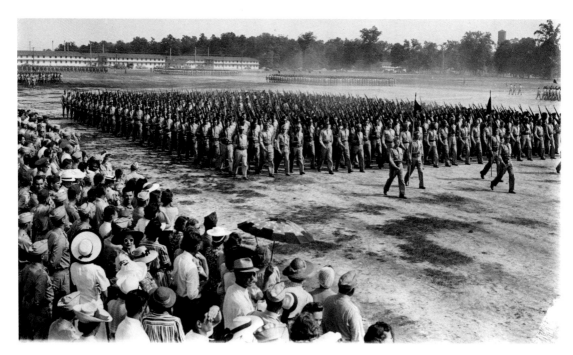

Hundreds of civilians and three generals of the nation's coast artillery training camps were spectators as more than 14,000 soldiers of the Fort Eustis Coast Artillery Replacement Training Center presented this formation as they marched in review on June 21, 1941, and shown on this Acme press photograph. On the reviewing stand were Brigadier General Harold F. Nichols, commanding general of Fort Eustis; Brigadier General John B. Maynard, commanding general at Camp Wolters, Texas, and Brigadier General Francis P. Hardaway, commanding general at Camp Callan, California.

In 1917, Jewish businessmen and brothers Nathan and Morris Peltz opened a ship chandlery business. After a hiatus while Nathan served in World War I, the brothers reestablished it in 1920 as the International Outfitting Company; it was renamed the Peltz Brothers by 1937. Nathan "Nat" Peltz, founder and senior partner of the firm, is shown in this 1941 photograph.

Peltz Brothers, located at 2300 West Avenue and shown here in 1941, survived the lean years of the 1920s and 1930s, and thrived during World War II when it received government contracts to outfit naval ships. Peltz Brothers had offices in both Newport News and Norfolk and remained in operation into the 1980s. The Chevrolet stack trucks date the photograph, which was taken for the company's twenty-fifth anniversary.

Pat Terry took this photograph of shipyard workers on a break in May 1942. *Farm Security Administration/Office of War Information Collection, Library of Congress*

The children of a black shipyard worker are shown here on their small subsistence farm in the Jefferson Avenue section of the city. The picture, taken by Pat Terry in May 1942, was part of an important Farm Security Administration effort to document the lives of Americans, most especially black Americans. The children in this picture are feeding a goose through the fencing. *Farm Security Administration/Office of War Information Collection, Library of Congress*

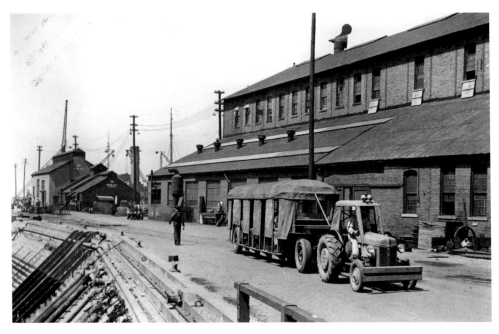

Buses that were once used to haul sightseers around the New York World's Fair were used on the grounds of Newport News Shipbuilding to speed the war effort by getting key men quickly around the yard. These "Shanghai Expresses" as they were nicknamed by workers crossed the yard on a regular basis in runs that took about seven minutes. Regular bus stops were set up and a schedule maintained. Here, in an Acme press photograph dated April 26, 1942, one of the buses is shown being towed from the waterfront section of the yard. In the background are the masts, stack and spars of a ship while at the left can be seen a portion of the huge dry docks.

This view of the *South Dakota*-class battleship USS *Indiana* (BB-58)'s forward main battery of sixteen-inch, .45 caliber Mark 6 guns was taken at Newport News, Virginia, on April 30, 1942, the day of her commissioning. The ship's main battery consisted of nine big guns arrayed in three, three-gun turrets on the centerline, two of which were placed in a superfiring pair forward, with the third aft. The secondary battery consisted of twenty five-inch, .38 caliber dual purpose guns mounted in twin turrets clustered amidships, five turrets on either side. At the time of *Indiana's* commissioning, she was also equipped with six quad forty-millimeter Bofors guns and sixteen single twenty-millimeter Oerlikon cannons. Note the anchor chains and capstains, armored conning tower and Mark 38 main battery director atop her superstructure. Fire control radar antennas have not yet been fitted atop her gun directors. *National Archives*

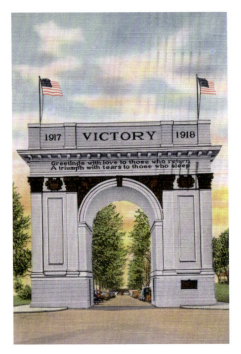

The Arch of Triumph, often called Victory Arch and shown on this 1943 linen era postcard, was built by the citizens of Newport News who funded it by a subscription. The original arch was a temporary structure erected at Twenty-fifth Street and West Avenue. The inscription on the arch was written by Robert G. Bickford who won a contest to have his verse inscribed on the arch. Bickford wrote: "Greetings with love to those who return, A triumph with tears to those who sleep." The arch was dedicated on April 13, 1919. As troops returned home they marched through the arch and received greetings from welcoming townspeople. The original structure was built of wood and plaster and decayed over time. The arch was rebuilt in granite and rededicated on May 30, 1962.

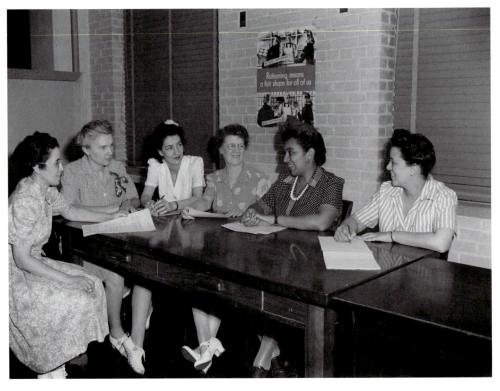

Mrs. Ethel R. Stephens, organizer of the Consumer Interest Council, a group of black housewives in Newport News, is shown in this Roger Smith July 1943 photograph making a report to the members of the Special Services Section of the Office of Price Administration concerning point rationing. Rationing was a necessary sacrifice everyone made during World War II. The women in the picture are (left to right): Mrs. Margaret Barr, Mrs. Anna B. Wilson, Mrs. Frances F. Friedman, Mrs. Stephens, Mrs. Frederica Warrick and Mrs. Fannie G. Williams. *Farm Security Administration/Office of War Information Collection, Library of Congress*

Four members of the 1942 Holy Cross University varsity football team lost no time having a "pigskin workout" after they arrived together at Fort Eustis to begin basic training as antiaircraft artillerymen. Private William Swiacki, of Southbridge, Massachusetts, is over the ball. In the backfield are (left to right): Private Bob Sullivan, North Andover, Massachusetts, fullback; Private Johnny Bezemes, Peabody, Massachusetts, halfback, and Private Raymond Ball, Clinton, Massachusetts, quarterback. This Acme picture is dated May 4, 1943. In the fall of 1942, these soldiers were part of one of the biggest football victories of the season when Holy Cross trounced Boston College, one of the nation's top teams that year, 55-12.

Trucks packed with huge sacks of mail backed up to the piers of the Hampton Roads port of embarkation at Newport News (shown on this Acme press photograph dated October 2, 1943); the loads were then dumped into cargo nets which, in turn, were immediately hoisted aboard waiting ships that carried the mail to combat troops, sailors and Marines fighting overseas. Letters and packages, correctly addressed, could reach men serving in Europe within ten days of mailing.

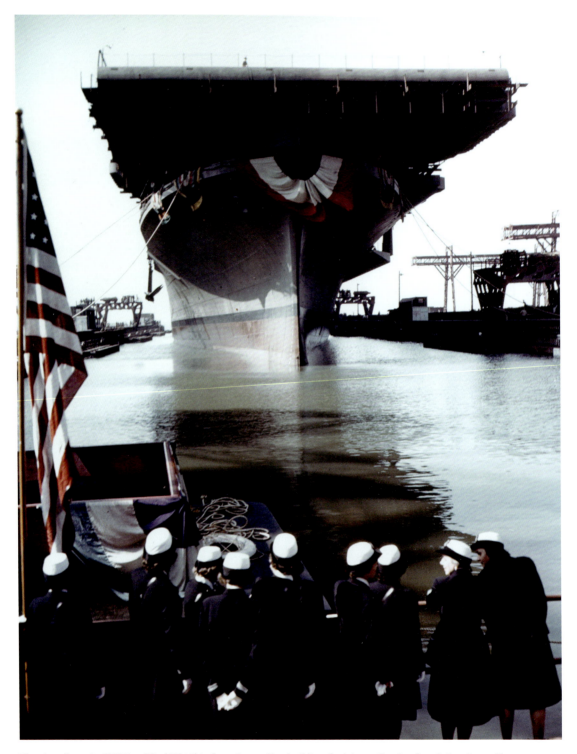

The aircraft carrier USS *Franklin* (CV-13) is floated out of her building dock immediately after christening at Newport News Shipbuilding and Dry Dock on October 14, 1943. Note the Women Accepted for Volunteer Emergency Service (WAVES) officers in the foreground. During World War II the WAVES were the women's branch of the United States Naval Reserve (USNR). The WAVES' director, Lieutenant Commander Mildred H. McAfee, USNR, was the *Franklin's* sponsor. *National Archives*

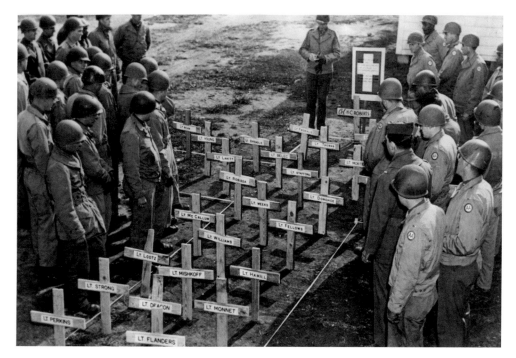

United States Army chaplain William J. Clements, of Philadelphia, Pennsylvania (center, background), read a "benediction" over the mock graves of officers who would have been killed had their trip through the mines technique school at Fort Eustis been the real McCoy. But the mines the men stumbled over were merely duds and so the men were able to attend their own "funeral services," a grim warning of what might happen someday in a combat zone if they didn't watch out for booby traps—or "minelins"—as they were called at Fort Eustis. The picture was taken on December 13, 1943, by an Acme press photographer.

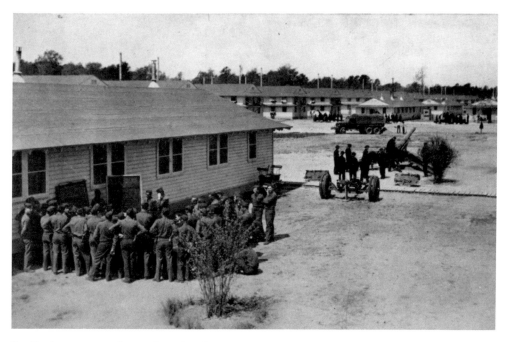

Fort Eustis was reopened as a military installation in August 1940 as the Coast Artillery Replacement Training Center. The scene on this World War II period postcard is of a lecture on fire control as it pertained to the three-inch anti-aircraft gun.

During World War II, as part of coast artillery training, men matriculating through Fort Eustis and later sent into combat working anti-aircraft batteries, worked with antiaircraft sixty-inch searchlights like the one shown here. Also, beginning in the World War II era, the primary mission of Fort Eustis has been United States Army transportation training, research and development, engineering, and operations, including aviation and marine shipping activities. Today, the army element of the post is currently under the command of the United States Army Training and Doctrine Command (TRADOC).

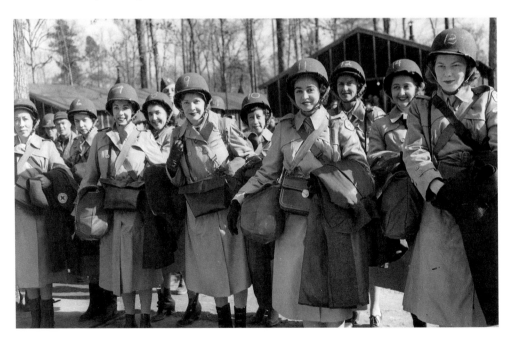

Red Cross workers assembled at Avenue C and Seventh Street at Camp Patrick Henry on February 27, 1944. Pictured in the front row (left to right) are Edna Elizabeth Dick of Williamsburg, Kentucky; Madeleine Carroll Hamilton, the famous English-American actress (married to Sterling Hayden, who changed his last name to Hamilton), and Marcia Hinrichs, Alexandria, Virginia. Standing in the back row are (left to right) are Megan Downey, Cleveland Heights, Ohio; Anne Hayes, Atlanta, Georgia, and Helen Hubbell, New York City. At the peak of her success in the 1930s and 1940s, Madeleine Carroll was the highest paid actress in the world. *National Archives*

IV

Growth and Change

Postwar Newport News entered a whole new phase of growth and development. The end of World War II introduced the world to nuclear power and thus a new source of peacetime energy. At the shipyard, already the premier constructor of aircraft carriers, secret talks began with the navy regarding the potential of nuclear-powered ships. With the onset of the Korean Conflict and a cold war with Soviet Russia, there was no disarmament like the one that had followed World War I but the former wartime facilities did begin to take on former and newfound uses. The port of embarkation was closed down by January 1946, and the tracks and docks were returned to the Chesapeake and Ohio Railway. North of the city, the barracks at Camp Patrick Henry were empty and much of the acreage turned over in 1949 to Patrick Henry Hospital for the Chronically Ill and Patrick Henry Airport. Decommissioned merchant and naval ships, many of which had been the famous Liberty and Victory ships, were towed up the James River to the reserve fleet anchorage off Fort Eustis. Newport News Shipbuilding closed the North Carolina Shipbuilding Corporation and brought many of the Wilmington personnel back to the Virginia Peninsula. Though the navy cancelled six capital ships at war's end, it did permit the yard to complete the aircraft carriers USS *Midway* (CV-41), lead ship of its class, and USS *Coral Sea* (CV-43) and the *Des Moines*-class heavy cruiser USS *Newport News* (CA-148), and later the supercarriers USS *Forrestal* (CV-59), lead ship of its class, USS *Ranger* (CV-61), USS *America* (CV-66), one of three *Kitty Hawk*-class ships, and USS *John F. Kennedy* (CV-67), the only ship of its class (a variant of the *Kitty Hawk*-class) and the last conventionally powered carrier built for the United States Navy.

One of the greatest projects undertaken at Newport News Shipbuilding after the war was the construction of the 990-foot superliner SS *United States*. This engineering marvel was built for the United States Lines as part of a secret cold war program to build the fastest ship in the world. The grand dame of ocean liners was christened July 31, 1951, and made its maiden voyage on July 3, 1952. Built at a cost of $78 million, *United States* was the fastest ocean liner to cross the Atlantic in either direction, attaining the incredible speed of fifty miles per hour, and even in her retirement retains the Blue Riband given to the passenger liner crossing the Atlantic Ocean in regular service with the record highest speed. The ship's construction was subsidized by the federal government, since *United States* was designed to allow conversion to a troop carrier should the need arise. The ship had accommodations for 2,000 passengers and a crew of 1,000.

By war's end Newport News had arguably outgrown its original boundary. The cities of Warwick and Hampton were separately constituted in 1952, each of substantial land area, Warwick being the largest of the two. By comparison, Richmond's land area was about half of Warwick's at that time. When Newport News and Warwick eventually merged on July 1, 1958, the population of newly consolidated Newport News was just over 113,000, and by 1969 that figure would rise to 137,000. The consolidation of Newport News and Warwick created a city of 65 square miles. The 1958 merger by mutual agreement with the city of Warwick effectively removed the political boundary that had run adjacent to Mercury Boulevard; this major north-south roadway carries U.S. Route 258 between the James River Bridge and the Coliseum-Central area of adjacent Hampton. At the time, the county was mostly rural, although along Warwick Boulevard north of Mercury Boulevard, Hilton Village was developed during World War I as a planned community. Beyond this point to the west, much of the city took on its unmistakable suburban character. Many neighborhoods were developed, some around a number of former small towns.

Miles of waterfront along the James River, and tributaries such as Deep Creek and Lucas Creek, were occupied by higher-end single family homes. In many sections, wooded land and farms gave way to subdivisions. Even at the northwestern reaches, furthest from the traditional downtown area, more residential development occurred. Much land was set aside for natural protection, with recreational and historical considerations. Along with some newer residential areas, major features of the northwestern end included the reservoirs of the Newport News water system (which include much of the Warwick River), the expansive Newport News Park, a number of public schools, and the military installations of Fort Eustis and a small portion of the Naval Weapons Station Yorktown. At the extreme northwestern edge adjacent to Skiffe's Creek and the border with James City County sprung the Lee Hall community, which retains historical features including the former Chesapeake and Ohio Railway station (the only surviving Chesapeake and Ohio structure of its kind on the lower Peninsula, and the only survivor of five such depots that originally populated Warwick County, the others being Oriana, Oyster Point, Morrison and Newport News) which served tens of thousands of soldiers based at what became nearby Fort Eustis during World War I and World War II.

At the end of the 1950s, in 1957, Newport News Shipbuilding was awarded a contract for the aircraft carrier USS *Enterprise* (CVN-65), the world's first nuclear-powered aircraft carrier and the eighth United States naval vessel to bear the name. Like its predecessor of World War II fame, the carrier was nicknamed the "Big E." At 1,123 feet, *Enterprise* was the longest naval vessel in the world, a record which still stands. The carrier's 93,284-long-ton displacement ranked her as the twelfth heaviest supercarrier, after the ten carriers of the *Nimitz*-class and the USS *Gerald R. Ford* (CVN-78). *Enterprise* had a crew of some 4,600 service members. The only ship of its class, *Enterprise* was, at the time of inactivation, the third oldest commissioned vessel in the United States Navy after the wooden-hulled USS *Constitution* and USS *Pueblo* (AGER-2). "Big E" became the fourth aircraft carrier in naval history to record 400,000 arrested landings on May 24, 2011. The milestone landing was made by an F/A-18F Super Hornet piloted by Lieutenant Matthew L. Enos and Weapon System Officer Lieutenant Commander Jonathan Welsh from the Red Rippers of Strike Fighter Squadron Eleven (VFA-11). *Enterprise* was officially inactivated December 1, 2012, and was put into an extensive terminal offload program leading up to the carrier's eventual decommissioning. For more than two centuries, *Enterprise* sailors set the standard for excellence aboard the eight ships to proudly bear the name, and will continue to do so

upon the future commissioning of the ninth *Enterprise* (CVN-80). *Enterprise*'s replacement is the USS *Gerald R. Ford*.

Back to the postwar period following World War II, there were positive steps forward for the Newport News port of significant scope and economic impact. Significantly, in those post World War II years Esso Standard Oil Company established a petroleum terminal and farm and fourteen tanks with a combined capacity of twenty-two million gallons, and used bunkering ships moored at the Chesapeake and Ohio's piers 14 and 15. Esso Standard's facilities provided for receiving bulk lots of gasoline, kerosene, solvents, jet fuels, bunker oil, diesel fuel and heating oil from oceangoing tankers, which were in turn distributed by tank trucks, railway tank cars, pipelines and barges. There was also a storage depot for Union Ore Corporation, a subsidiary of Union Carbide Chemical Company. The depot, on a 360-acre site in what was formerly Warwick, was designed largely as storage for manganese and chrome ore; the ore was brought in through a new Chesapeake and Ohio ore-handling pier, and was in turn redistributed to Union Carbide Chemical plants. The city's worst waterfront fire occurred at the Esso bunker terminal facility near the municipal small boat harbor on April 23, 1958.

The immediate postwar period also paved the path, in 1946, for air service to the Peninsula when the Virginia General Assembly passed legislation creating the Peninsula Airport Commission (PAC) to determine a location for and establish a new commercial airport to serve the cities of Newport News and Hampton. An agreement was reached with the United States War Asset Administration in 1947 to transfer 924 acres of the aforementioned former Camp Patrick Henry to the PAC as the site for the new airport. A Nike missile air defense base, known as N-85, still exists on the property, though abandoned since the mid-1960s. The airport was originally named Patrick Henry Airport and the first runway built was Runway 2–20, a 3,500-foot runway, followed by Runway 6–24 (later redesignated as Runway 7–25). Commercial airline service began in November 1949. The airport was first serviced by Piedmont Airlines and Capital Airlines. In 1951, the original passenger terminal was damaged by a fire. An upgraded traffic control tower was constructed and began operation and Runway 6–24 was extended in 1952 to 5,000 feet for larger four-engine aircraft. A new passenger terminal was opened in 1955. Between 1952 and the 1970, three other airlines—United, National, and Allegheny (later USAir)—extended service to the airport. Both runways were extended during this period to their current lengths: Runway 2-20 to 6,526 feet and Runway 7-25 to 8,003 feet. The airport was renamed Patrick Henry International Airport in 1975. A United States Customs facility was added to the passenger terminal building to allow international flights (both commercial and corporate) access to the airfield. The airport now consists of 1,800 acres, with most of it in the city of Newport News and nearly half of the airfield with runways 2-20 and 7-25 in York County. On December 19, 1980, the *Daily Press* reported a committee authorized by the PAC recommended to then-airport executive director Michael White that the airport change its name to Newport News/Williamsburg International; this change would not take place until ten years later. Until the 1990s, part of the original terminal building named the Flight Services Building was home to the National Weather Service. Weather reports and emergency alerts were broadcast on radio stations and weather frequencies during severe weather from the airport. When the original control tower was shut down in July 2007 with opening of the state of the art 147-foot tall new tower, it had been the oldest operating control tower on the east coast with continuous service for fifty-five years.

With an economy based on shipping, evidenced by the thousands of ships entering Hampton Roads each year, it became clear that competitive interests in the port that had

long existed between Norfolk, Portsmouth and Newport News needed to change. Going forward, this would mean consolidation of facilities and interdependent communities and industries, a merger of old rivalries into an economically compatible body. While the Norfolk Port and Industrial Authority had been proactive in the development of the old United States Army Intermediate Depot off Hampton Boulevard, converting it to the Norfolk Tidewater Terminals (later Norfolk International Terminals), for example, it had no control over similar activities in Portsmouth and Newport News, and likewise for Norfolk's competitor cities. Shipping terminals in Norfolk, Portsmouth and Newport News competed against one another for business. During a speech to the Virginia Conference on World Trade on October 19, 1967, Norfolk mayor Roy B. Martin Jr. stated that he thought there should be one body in control of port terminals in Hampton Roads. At that time the Virginia State Ports Authority had no power over the Norfolk Port and Industrial Authority, the Portsmouth Port and Industrial Commission and the Peninsula Ports Authority of Virginia, the agencies charged with responsibility for port development within their own communities without regard to what the other cities were doing to increase their share of the export and import market. Martin's public call for unification of the ports in Hampton Roads was the first by any city official in the region. A proposal from the cities asking for state unification soon followed. The commonwealth of Virginia would eventually purchase the cities' terminals under the auspices of the Virginia Port Authority.

As Newport News moved into the last quarter of the twentieth century, it faced issues closer to home for long-time city residents: a deteriorating downtown. The city's once swanky West End district as well as pockets of historic structures above the shipyard and within the commercial district on Washington Avenue had been allowed to decline and without historic preservation advocacy most of these homes and buildings fell to the wrecking ball and in the process a once vibrant downtown lost its character. The Newport News Redevelopment and Housing Authority (NNRHA) spent over $4 million in federal and local urban redevelopment funds to raze the downtown in the hope of attracting new stores and office towers. A new city hall was erected at the south end of Washington Avenue as the centerpiece of a reimagined civic center of courthouses, a federal building, and the new Victory Arch that replaced the temporary structure erected after World War I. The new arch was rebuilt in stone and rededicated on May 30, 1962. On Memorial Day, 1969, the American Legion donated an eternal flame to the arch site. Standing fourteen feet high the eternal flame that sits under the arch was cast in bronze by Womack Foundry of Newport News; the casting was handcrafted by Ernest D. Womack, the foundry's founder and president.

Newport News was at the center of a series of large mergers in the 1960s that would fix the city's role as a major player in the national economy. The Chesapeake and Ohio Railway continued to be one of the more profitable and financially sound rail enterprises in the United States into the 1960s, and in 1963, under the guidance of Cyrus S. Eaton, helped start the modern merger era by affiliating with the Baltimore and Ohio Railroad, one of the oldest railroads in the United States and the first common carrier railroad. Avoiding a mistake that would become endemic to later mergers among other lines, a gradual amalgamation of the two lines' services, personnel, motive power and rolling stock, and facilities built a new and stronger system, which was ready for a new name by 1972. Under the leadership of the visionary Hays T. Watkins Jr., the Chesapeake and Ohio, Baltimore and Ohio and Western Maryland Railway became Chessie System, officially taking on the name that had been used colloquially for so long for the Chesapeake and Ohio. Chessie was a mascot kitten that had been used in advertisements since 1933. According to the railroad's history, it was under

Watkins' visionary leadership that Chessie System merged with Seaboard System Railroad, commonly called the Chessie and Seaboard (itself a combination of great railroads of the Southeast including Seaboard Air Line Railroad, Atlantic Coast Line Railroad, Louisville and Nashville Railroad, Clinchfield Railroad and others), to form a new mega-railroad: CSX Transportation. Western Maryland was merged into Baltimore and Ohio on May 1, 1983; Baltimore and Ohio was merged into Chesapeake and Ohio on April 30, 1987, and Chesapeake and Ohio was merged into CSX Transportation on August 31, 1987. After acquiring forty-two percent of Conrail in 1999, CSX became one of four major railroad systems left in the country.

Aside from the major rail mergers that brought so much attention to Newport News, Tenneco, a Houston, Texas conglomerate engaged largely in gas transmission and in oil and chemicals, bought Newport News Shipbuilding in September 1968. From the death of Calvin B. Orcutt in 1911, Newport News Shipbuilding's presidents had come through the ranks at the yard but under Tenneco's ownership, this was not the case. None of the men who assumed the leadership of the yard from the time Tenneco took over would be a shipbuilder.

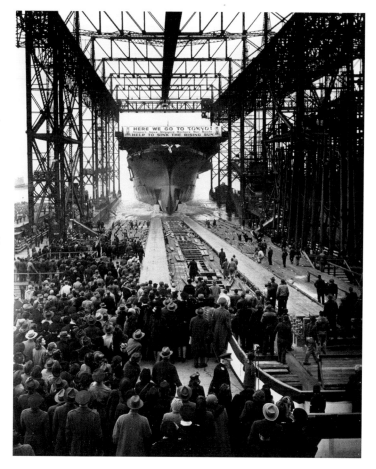

The USS *Boxer* (CV-21) slides down the ways during launching ceremonies at the Newport News Shipbuilding and Dry Dock Company on December 14, 1944. Note the banner spread across the front of *Boxer*'s flight deck, proclaiming: "Here We Go to Tokyo! Newport News Shipyard Workers' War Bonds Help to Sink the Rising Sun." The *Boxer* was commissioned on April 16, 1945. *United States Naval History and Heritage Command*

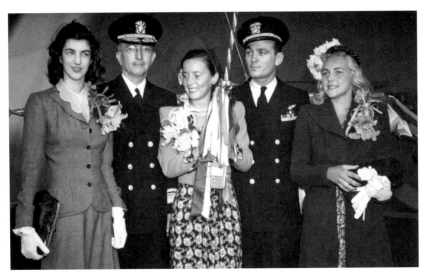

The USS *Midway* (CVB/CV-41) sponsor's official party (shown here, standing on the christening platform on March 20, 1945) included (left to right): Miss Fredericka Paterson, maid of honor; Rear Admiral Ormond Lee Cox, superintendent of shipbuilding, Newport News Shipbuilding; Mrs. Barbara Cox Ripley, sponsor and the widow of naval aviator lieutenant Bradford William Ripley II, killed in the Pacific; Lieutenant George Henry Gay Jr., USNR, and Mrs. Mary Buhl Aycrigg, maid of honor and the widow of Marine Corps aviator first lieutenant William Anderson Aycrigg II, assigned to Marine Fighting Squadron 422 (VMF-422) when he was lost on an April 25, 1944 flight from Tarawa to Nanomea that ran into foul weather. Unable to find the airfield at Nanomea, Aycrigg ditched his F4U-1D Corsair at sea; his body was never found. Barbara Ripley was the daughter of former Ohio governor James Middleton Cox, publisher of the *Miami Daily News*, three newspapers in Ohio and the *Atlanta Journal*. Notably, Gay was the TBD Devastator pilot assigned to Torpedo Squadron 8 (VT-8) operating from the USS *Hornet* (CV-8) during the pivotal Battle of Midway; of the thirty VT-8 aircrew who participated in this engagement, he was the sole survivor. *National Archives*

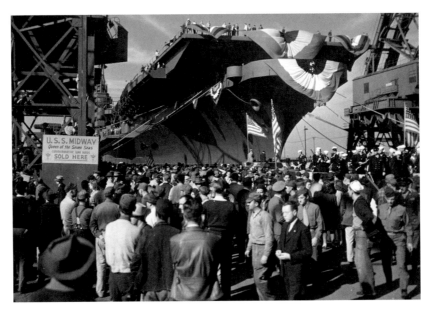

This is a view of the launching of the USS *Midway* (CVB/CV-41) on March 20, 1945, at Newport News Shipbuilding and Dry Dock. *National Archives*

Born March 29, 1918, in Virginia's Southampton County to Joseph and Ella Mae Ricks Bailey, actress and singer extraordinaire Pearl Bailey was reared in the Bloodfield neighborhood of Newport News. She first appeared in vaudeville and debuted on Broadway in *Saint Louis Woman* in 1946; this portrait of her is from that show and is a Carl Van Vechten gelatin silver photograph taken on July 5 of that year. *Library of Congress*

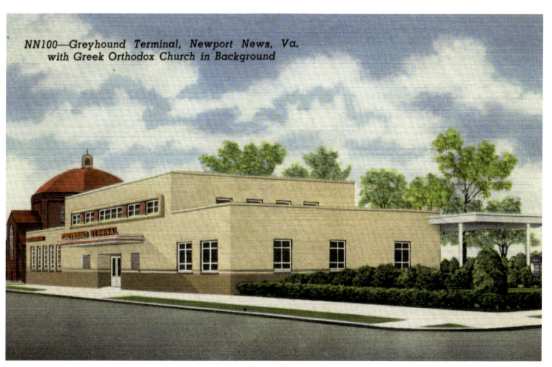

The Greyhound Bus Terminal, shown on this 1949 linen postcard, was located at 2601 West Avenue. The new, that year, Greek church of Saints Constantine and Helen, identifiable, far left, was on the corner of West Avenue at Twenty-sixth Street.

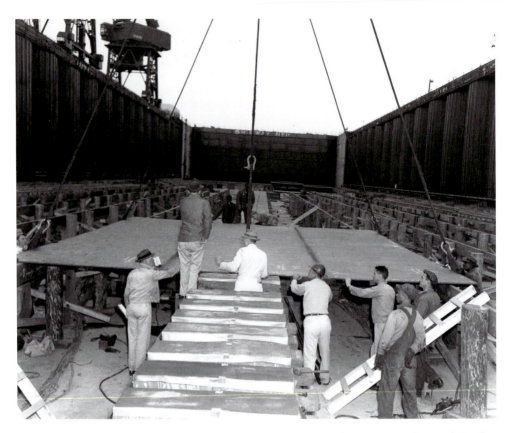

Above: Workmen lay the fifteen-ton keel plate and initial shell plate of the USS *United States* (CV-58) at Newport News Shipbuilding and Dry Dock Company on April 18, 1949. The aircraft carrier was cancelled a few days later, on April 23, and the ship was subsequently converted to a passenger liner. *National Archives*

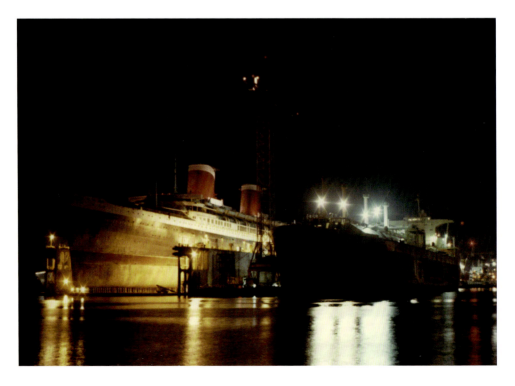

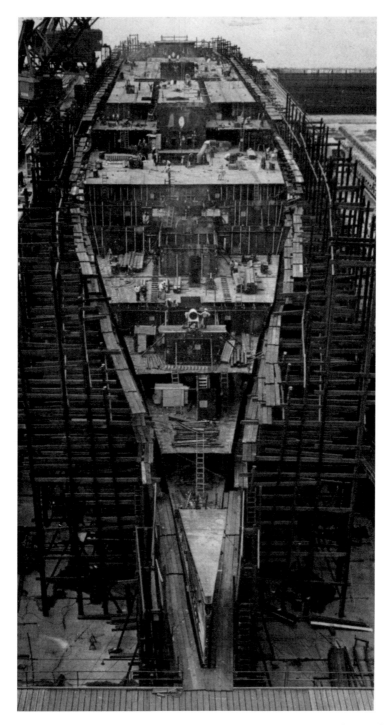

Above: Progress of construction of the 990-foot SS *United States*, the largest passenger ship ever built by an American shipbuilder, is shown in this picture, taken in 1950 in her dry dock at Newport News Shipbuilding.

Opposite below: The SS *United States*, shown in dry dock at Norfolk Shipbuilding and Dry Dock Company in this April 1980 Tal Carey photograph, operated uninterrupted in transatlantic passenger service until November 14, 1969. Dubbed "America's Flagship," what may arguably be the greatest ocean liner in history, built by Newport News Shipbuilding, was towed to Pier 84 in Philadelphia in 1996, where it remained until being initially sold for scrap.

Left: This 1950 period advertisement for Patrick Henry Airport features airport manager Eugene C. Marlin (inset), and linemen (left to right) T. R. Meacham and John T. Stanaway Jr. servicing the aircraft.

Below: Secretary of Defense Charles Wilson (on the rostrum) addresses a huge crowd at Newport News Shipbuilding during the christening ceremony of what was then the nation's largest aircraft carrier—USS *Forrestal* (CV-59)—on December 11, 1954. Forrestal, named for the first secretary of Defense James Forrestal, was the first completed supercarrier and the lead ship of its class.

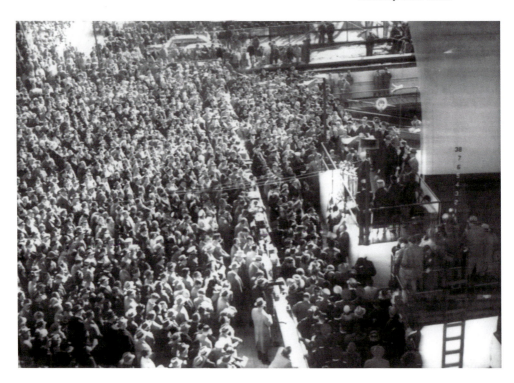

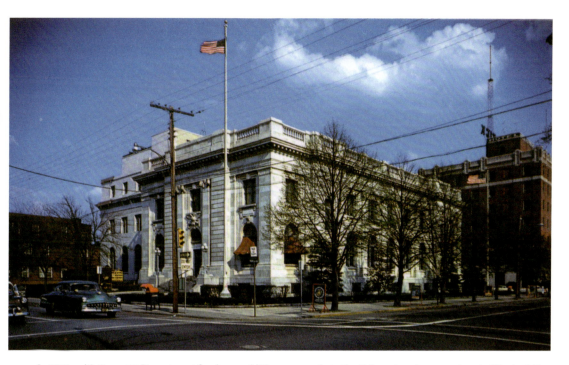

In 1941, with Treasury Department funds, an addition was made to the U.S. custom house and post office building on West Avenue between Twenty-fifth and Twenty-sixth Streets, shown on this chrome postcard, published about 1955. After a new federal court building was erected at 2400 West Avenue in 2007, this impressive historic structure continues to house a post office and a notable collection of New Deal artwork.

Fire destroyed the original Hotel Warwick on November 14, 1961, leaving the annex (shown here, 1955) at the southeast corner of Twenty-fifth Street and West Avenue. Built in 1928, the annex is a seven-story brick building in an eclectic Gothic Revival/Art Deco style; it features terra cotta tile ornamentation and a continuous terra cotta and brick false parapet. A two-story addition was added to the rear of the building in 1962, after the fire that took the Old Dominion Land Company's original hotel. When it was built in the late 1920s, the annex was the first skyscraper, first tower hotel and first fireproof hotel in Newport News.

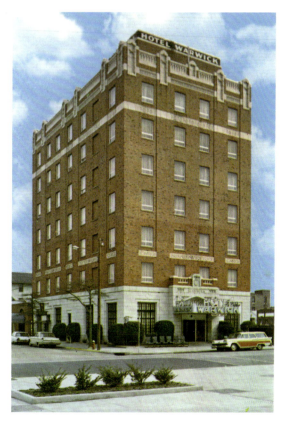

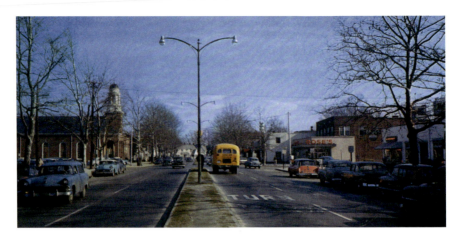

Looking down Warwick Boulevard from Hilton Village's Main Street on this 1958 chrome postcard, identifiable landmarks are the First United Methodist Church, known until 1954 as the Hilton Village Methodist Church (left) and a Rose's store (right). The church's history began with the development of Hilton Village; on November 17, 1919, the Virginia Annual Conference of the Methodist Episcopal Church-South sent Reverend Daniel Gregory Claiborne Butts to be the first pastor of this Methodist church in the village. The sanctuary shown here was completed in 1954 and along with it came the first name change from Hilton Village Methodist Church to the First Methodist Church of Newport News. In 1969, the General Conference of the Methodist Church approved a merger between this church and the Evangelical United Brethren Church; it was from that merger that the church got its present name: the First United Methodist Church, still located in the 1954 building at 10246 Warwick Boulevard.

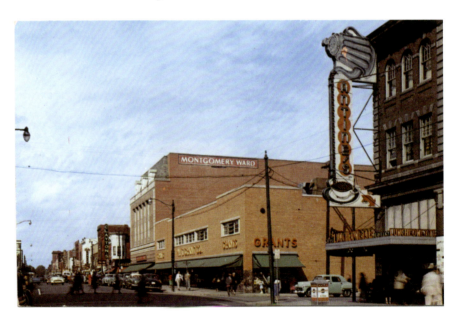

This scene from Washington Avenue at Twenty-eighth Street, from a 1960 chrome postcard, shows the iconic Antine's Luncheonette (foreground), remarkable for its animated neon coffeepot and cup sign and for its waffles and milkshakes. Antine's sign reflected the advancement of neon signage after World War II, when sequentially lit, animated, flashing and large neon murals began to reappear. During this period sequentially lit or "spelling" neon, animated neon, flashing neon and large neon murals began to reappear. The luncheonette was owned by Harry Jerome Antine, a Russian immigrant, and his wife, the former Olie Lucille Calder, a Thunderbolt, Georgia native who, along with her husband, had been Hampton residents since 1949.

Right: The figurehead from the iron ship *Calbuco*, built as *Circe* at Glasgow, Scotland, in 1885, is shown on this 1960 chrome postcard of what was, at that time, the main gallery of the Mariners' Museum. The *Calbuco* was the last full-rigged sailing cargo-carrying ship to round Cape Horn and was broken up for scrap at Genoa, Italy, in 1948.

Below: The main room of the Mariners' Museum as it looked on this 1960 period chrome postcard shows a portion of the institution's collection, to include ship models, figureheads, and other maritime artifacts.

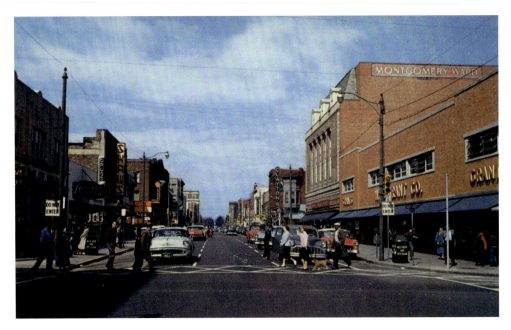

Looking down Washington Avenue from Twenty-eighth Street (just beyond Antine's) this 1961 chrome postcard includes the Montgomery Ward, opened in 1937, and the W. T. Grant, opened in 1949, on the right. The Clayton's men's shop is the red brick building just beyond Montgomery Ward. Both department store buildings, remodeled, still stand and are used by Newport News Shipbuilding. On the opposite side of the street, between Twenty-eighth and Twenty-ninth Streets, is the Bank of Virginia (foreground), which opened at that location about 1955; it, too, is still standing and used by the shipyard. Beyond the bank there was a People's Drug Store and Shaw's, a jewelry store. This unused postcard also had a surprise on the reverse: an authenticated autograph of astronaut Virgil I. Grissom.

Civil rights activist Rosa McCauley Parks (far right), who the United States Congress dubbed "the first lady of civil rights" and "the mother of the freedom movement" after her death at age 92 on October 24, 2005, was photographed in Newport News during an August 1971 visit with the niece and nephews of her Detroit, Michigan friend and fellow activist Patricia Cadwell. *Library of Congress*

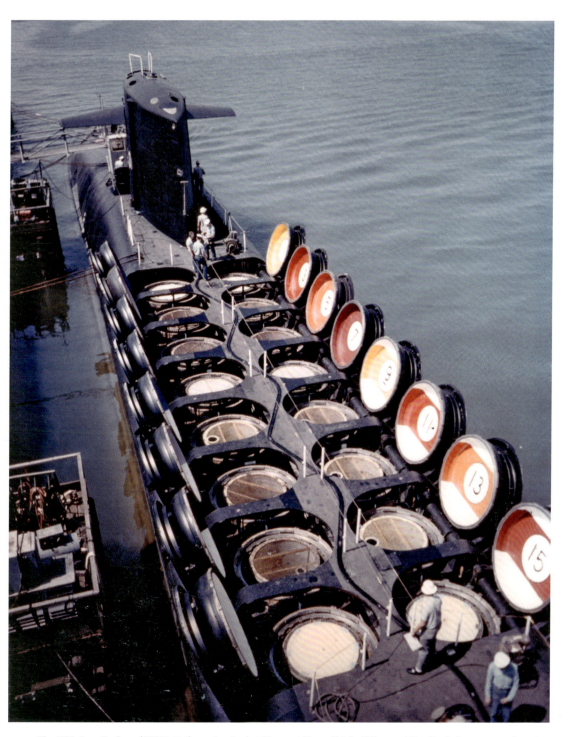

The USS *Sam Rayburn* (SSBN-635) was berthed at Newport News Shipbuilding and Dry Dock Company undergoing tests between 1964 and 1965. Note the open tubes for Polaris missiles with hatch covers colored and numbered in billiard ball-style. *National Archives*

V

Toward a New Millennia

Newport News grew in population from the 1960s through the 1990s, and by 2013 stood at 180,000 residents. Much of the newer commercial development has been along the Warwick Boulevard and Jefferson Avenue corridors, with newer planned industrial, commercial, and mixed development such as Oyster Point, Kiln Creek and the City Center; another is Port Warwick. The city began to explore the New Urbanism movement as a way to develop the midtown areas of the city. City Center at Oyster Point was developed out of a small portion of the Oyster Point Business Park and has been touted as the city's new "downtown" due to its central location in Newport News and the Peninsula; it opened in phases from 2003 through 2005. The city invested $82 million of public funding in the project, according to a June 5, 2005 *Daily Press* editorial.

Closely following Oyster Point, Port Warwick opened as an urban residential community in the new midtown business district. Fifteen hundred people now reside in the Port Warwick area, which includes mixed-use housing for a broad range of residents, from retired persons to off-campus housing for Christopher Newport University students, upscale restaurants and shopping opportunities to a three-acre city square where festivals and other events take place; the area is named after the fictional place in the William Styron novel *Lie Down in Darkness*.

The first incarnation of what is now the Virginia Living Museum on J. Clyde Morris Boulevard was the Junior Nature Museum and Planetarium, opened in 1966 under Virginia governor Mills E. Godwin Jr. and cofounded by the Junior League of Hampton Roads and the Warwick Rotary Club. A decade later, in 1976, the facility was expanded and a new focus on physical and applied sciences was added to the existing natural sciences; at this time it was renamed the Peninsula Nature and Science Center. The museum began its transformation to a "living museum," incorporating living exhibits and land preservation together with traditional exhibits, in 1983, following the example of the Arizona–Sonora Desert Museum; it reopened as the Virginia Living Museum in 1987 under Virginia governor Gerald L. Baliles. The museum expanded throughout the 1990s, opening the Coastal Plain Aviary in 2001 and a 62,000-square-foot museum building in 2004. The main building features animals living in several exhibits that depict the many environments of Virginia, including the coastal plain, the Piedmont, an Appalachian Mountain cove, a cypress swamp, and an underground, as well as a gallery of nocturnal life. Outdoors, the museum features the 5,500-square-foot aviary, a butterfly garden, and a three-quarter-mile boardwalk with animals living in their natural habitats, including bobcats, river otters, pelicans, and red wolves.

In the port, consolidation strengthened Newport News' position as a leader in international commerce. Hampton Roads, including the immediate reaches of the James River, has twenty-five square miles of readily accessible waterways and a prime location, just eighteen miles from open sea, and it offers ships with the heaviest cargoes the convenience of steaming in and out of fifty-foot-deep, obstruction-free channels. Just as it did more than half-century ago, the port of Virginia continues to set records and benchmarks. The port ranks as one of the leading ports in the United States in total foreign waterborne commerce. In general cargo, containerized and break bulk cargo, it is the second largest port on the United States East Coast, just behind New York/New Jersey. Between 1982 and 2001, general cargo tonnage at Virginia's state-owned ports facilities increased from two-and-a-half million tons in 1982 to eleven-and-a-half million tons in 2001, an unmatched growth record among United States ports. In terms of total cargo, which includes container, break bulk and bulk cargo, the port handled over thirty-seven million short tons. The port's phenomenal growth is due, in large measure, to the unification of the ports of Hampton Roads, including key facilities at Norfolk International Terminals and Portsmouth Marine Terminal on the Elizabeth River. In 1981 the Virginia General Assembly passed landmark legislation designed to bring the ports under a single agency, the Virginia Port Authority, with a new, single operating company, Virginia International Terminals (VIT). Also managed by Virginia International Terminals are the Newport News Marine Terminal (NNMT) and the Virginia Inland Port, located at Front Royal, Virginia.

Prior to the beginning of port unification in 1971, the Peninsula Ports Authority of Virginia (PPAV) owned the Newport News Marine Terminal, and Chesapeake and Ohio Railway (now CSX) operated it. In the late 1960s, Pier B entered service and construction of Pier C began. When, in 1971, the PPAV and Chesapeake and Ohio conveyed their rights to NNMT to the Virginia Port Authority (VPA), Pier C had not yet been completed. One of the requirements of the contract stipulated that the VPA had to obtain state funding to finish the project. In 1972, the Virginia General Assembly appropriated the necessary funds to do it. The Chesapeake and Ohio remained the operator of NNMT until 1982, when the VPA board of commissioners authorized Virginia International Terminals to take over operations. In 1983, the VPA purchased twenty-two acres of land adjacent to NNMT from CSX, then leased the land back to the railroad company for two years while it built a repair along existing track. In the 1990s, NNMT was in receipt of a $10 million entrance complex, an interchange, scales, an administration building, twenty-seven acres of paved cargo space, and an extension to Pier C. In 1994, the Nissan Import Auto Operations facility, previously located at Norfolk International Terminals, relocated to a newly developed twenty-five-acre space at NNMT.

Newport News Marine Terminal today is the Virginia Port Authority's main break-bulk and roll-on/roll-off facility. The terminal occupies approximately 165 acres on the north bank of the James River. The facility offers 60 acres of outside storage and 968,000 square feet of covered storage space. Vessels have access to two piers with four vessel berths, containing 3,480 feet of berth space, with draft depth as deep as 40 feet, accommodating vessels 850 feet in length. The facility also contains 33,900 feet of rail provided by CSX. In addition, NNMT has a roll-on/roll-off ramp on Pier C South to deliver heavy-lift such as power plant equipment for delivery via water. NNMT provides direct, on-dock rail service with CSX, with the ability to transfer with Norfolk Southern in Richmond. NNMT has a permanent roll-on/roll-off ramp for loading/unloading rail cars with construction and agricultural equipment, another benefit to NNMT customers. In 2009, the port consolidated various cargo handling operations at NNMT and began focusing entirely on break-bulk and roll-on/

roll-off operations. In October 2011, a 100,000-square foot warehouse was constructed to handle additional break-bulk storage. NNMT has since been able to offer potential customers the opportunity to build additional warehouses or specialized cargo handling facilities if opportunities present themselves.

In the 1970s, Newport News Shipbuilding launched two of the largest tankers ever built in the western hemisphere and also constructed three liquefied natural gas carriers—at over 390,000 deadweight tons, the largest ever built in the United States. The shipyard and Westinghouse Electric Company jointly formed offshore power systems to build floating nuclear power plants for Public Service Electric and Gas Company. In the 1980s, the shipyard produced a variety of navy ships and submarines, including *Nimitz*-class nuclear aircraft carriers and *Los Angeles*-class nuclear attack submarines. Since 1999 Newport News Shipbuilding has produced only warships for the navy. Of note, in July 1989 the United States Navy commissioned the third naval vessel named after the city with the entry of the *Los Angeles*-class nuclear submarine USS *Newport News* (SSN-750), built at the shipyard, into active service. The submarine was initially commanded by Commander Mark B. Keef and the city orchestrated a public celebration of the event, attended by Vice President of the United States Dan Quayle and many other dignitaries.

The years to come would demonstrate to the nation that the vision of Collis Huntington was alive and well at Newport News Shipbuilding and that the future of his enterprise would remain secure into a new millennia despite multiples changes of ownership and the tumult of dealing with the ebb and flow of the nation's defense budgeting process. In 1968, Newport News had merged with Tenneco Corporation but just under thirty years later, in 1996, Tenneco initiated a spinoff of Newport News into an independent company: Newport News Shipbuilding. This was short-lived. On November 7, 2001, Northrop Grumman entered an agreement to purchase Newport News Shipbuilding for $2.6 billion. This acquisition created a $4 billion shipyard called Northrop Grumman Newport News. Less than a decade later, on January 28, 2008, Northrop Grumman Corporation realigned its two shipbuilding sectors, Northrop Grumman Newport News and Northrop Grumman Ship Systems, into a single sector called Northrop Grumman Shipbuilding, and a little over three years later, on March 15, 2011, Northrop Grumman announced the spin-off of this sector into a separate company that is now Huntington Ingalls Industries.

"Our strategy," said C. Michael "Mike" Petters, president and CEO of Huntington Ingalls Industries, at the time of the spin-off, "is to better align our business with the U.S. Navy's priorities and to continue improving our shipbuilding performance while meeting our customer commitments. Operating as an independent company will allow us greater focus and agility to accomplish these important objectives, which should create significant value for our shareholders."

The Huntington Ingalls Industries name reflects the long-standing legacies of the two shipbuilding business divisions of the new entity: Newport News Shipbuilding and Ingalls Shipbuilding. Collis P. Huntington founded Newport News Shipbuilding in 1886, and Ingalls Shipbuilding was established in 1938 by the Ingalls Iron Works of Birmingham, Alabama, a company founded by the Ingalls family.

"Incorporating the names of our founding families and legacy companies into our new enterprise will build upon our 125-year tradition of demonstrated commitment to quality, customer focus and building the best military ships in the world," Petters continued. "I am very excited about our future, about the strength and depth of our leadership team, and the skill and dedication of our shipbuilders."

Work today at Huntington Ingalls includes the construction of the *Gerald R. Ford*-class aircraft carriers, the refueling and complex overhaul of *Nimitz*-class aircraft carriers, construction of *Virginia*-class submarines, submarine design and life-cycle management, as well as fleet services for naval ships all over the world. The company is also constructing *San Antonio*-class amphibious transport dock ships and an *America*-class multipurpose amphibious assault ship and has built 28 of 62 *Arleigh Burke*-class destroyers with long-lead materials awarded on the first two ships in the continuation of the program. Recently, the company was awarded a fourth National Security Cutter construction contract for the United States Coast Guard. The shipyard is a major employer—the largest industrial employer in the commonwealth of Virginia—not only for Newport News and the lower Virginia Peninsula, but also portions of Hampton Roads south of the James River and the harbor, portions of the Middle Peninsula region, and even some northeastern counties of North Carolina.

At the end of the twentieth century and the beginning of another, Collis Huntington's legacy lives, not only in the railroads and shipyard that survived him, but in arts institutions and public spaces left behind by his family, most especially Henry and Archer Huntington. The footprint and fabric of the city of Newport News, in its salad days, developed with and around his great enterprises and survives today as a community founded on Collis Huntington's confidence in its success, through lean, hard times, war and peace. As Robert Powell observed in his September 25, 2011 *Virginia Business* article,[7] the Huntington Ingalls name reminds us of two men who were pillars of America's shipbuilding industry, and in the case of Huntington, much, much more.

This is a distant bow view of the *Los Angeles*-class nuclear-powered attack submarine USS *Buffalo* (SSN-715) and guests attending the launching ceremony at Newport News Shipbuilding on May 8, 1982. The contract to build her was awarded to the shipyard on February 23, 1976, and her keel was laid down on January 25, 1980. The submarine was not commissioned until November 5, 1983, more than a year after the launching ceremony shown here. *National Archives*

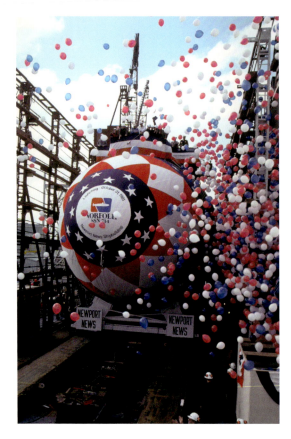

Left: Red, white and blue balloons are released at the bow of the *Los Angeles*-class nuclear-powered attack submarine USS *Norfolk* (SSN-714) during its launching ceremony at Newport News Shipbuilding and Dry Dock Company on October 31, 1981. *Norfolk* was decommissioned on December 11, 2014, at her homeport of Naval Station Norfolk in Virginia. *National Archives*

Below: Barbara Bush, sponsor, breaks the traditional bottle of champagne across the bow of the *Los Angeles*-class nuclear-powered attack submarine USS *Houston* (SSN-713) during the launch ceremony at Newport News Shipbuilding and Dry Dock Company on March 21, 1981. Standing behind Mrs. Bush is her husband, then vice president George H. W. Bush. *National Archives*

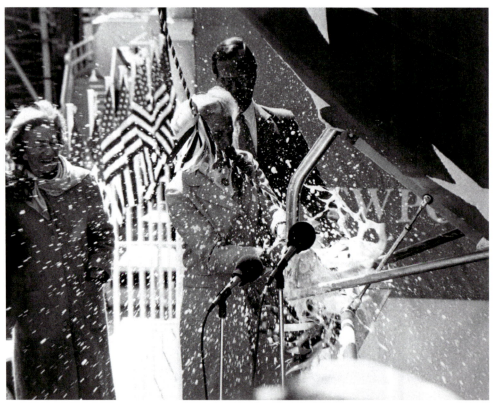

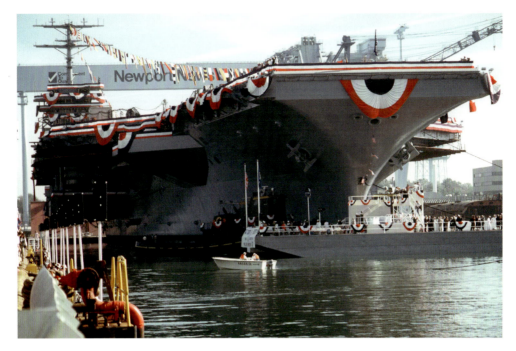

A starboard bow view of the nuclear-powered aircraft carrier USS *Theodore Roosevelt* (CVN-71) during its launching ceremony at Shipway 12 at Newport News Shipbuilding is shown in this October 27, 1984 photograph. The speaker's podium and the VIP seating area are located on the barge under the ship's bow. The shipyard's 900-ton capacity gantry crane is visible in the background. *National Archives*

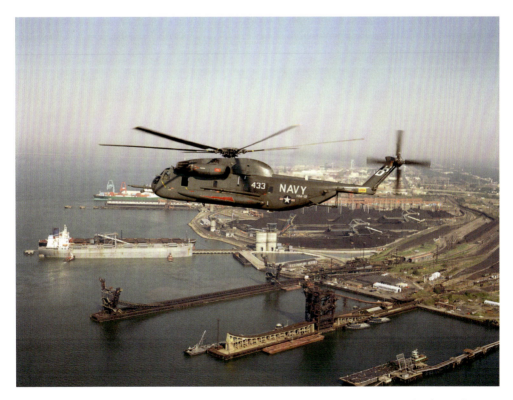

This is an air-to-air port side view of a Helicopter Mine Countermeasures Squadron Twelve (HM-12) RH-53 Sea Stallion helicopter flying over the coal terminal at Newport News on October 1, 1984. *National Archives*

The Davis and Kimpton Brickyard, located on the west bank of the Warwick River approximately four miles upstream from its confluence with the James River on Mulberry Island, is a unique and well-preserved example of a brick manufacturing plant and associated technology which was revolutionizing regional industrial patterns at the turn of the twentieth century. The brickyard furthermore is directly related to the development of Newport News during an historically important period of rapid growth that necessitated the establishment of manufacturing facilities to supply the increased demand for construction materials. This photograph and others of the site included herein were taken by Ronald A. Thomas in March 1986, and the photograph here is of the remnants of a large brick kiln. *Library of Congress*

Davis and Kimpton Brickyard was a late nineteenth-early twentieth century industrial complex where brick was manufactured of locally-dug clay and a saw mill operated. Industrialization of the tract as a brickyard started in 1898, with the purchase of 36.75 acres of land from Joseph Nettles and the Bank of Hampton by John W. Davis and Alexander H. Kimpton. The sawmill was in operation at the site sometime prior to 1904, based on documentation in land records. Due to the establishment of Camp Eustis during World War I, the twenty-year ownership of the brickyard by Davis and Kimpton, and subsequently Davis, was terminated with the sale of the tract to the United States government in 1918. *Library of Congress*

Prior to its purchase by Davis and Kimpton, the brickyard tract was part of a 206-acre farm owned by Warwick County surveyor George W. Fitchett and Colonel Thomas Tabb in 1882. The purchase of the property by Joseph Nettles resolved the decade-long disposition of the Thomas G. H. Curtis or "Home" tract on Mulberry Island, caused by the death and bankruptcy of Curtis in 1870. The Curtis property had been bought at auction by Fitchett, and several months later he and Tabb sold it to William L. and John H. Young. When the Youngs defaulted on the note, the property went back to Fitchett and Tabb in 1876. This is a view of the remnants of the old Davis and Kimpton wooden pier, looking north. *Library of Congress*

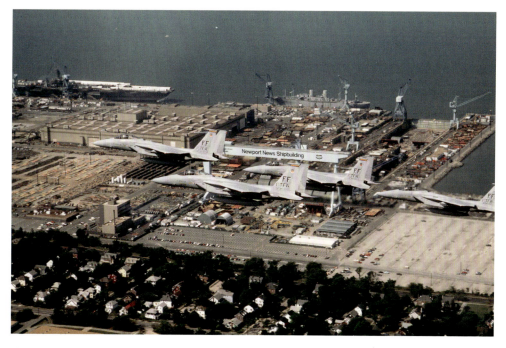

This is an air-to-air port side view of four F-15 Eagle aircraft from the First Tactical Fighter Wing, based at Langley Air Force Base in Hampton, in formation over Newport News Shipbuilding on August 5, 1986. *National Archives*

This view of the equipment on the dock below the nuclear-powered aircraft carrier USS *Dwight D. Eisenhower* (CVN-69) was taken on November 1, 1986, at Newport News Shipbuilding. The ship was undergoing overhaul at the yard. *National Archives*

The nuclear-powered aircraft carrier USS *Dwight D. Eisenhower* (CVN-69) was undergoing overhaul at Newport News Shipbuilding and Dry Dock Company when this aerial photograph was taken on April 2, 1987. *National Archives*

Above: This is a starboard bow view of the nuclear-powered attack submarine USS *Newport News* (SSN-750) underway for sea trials on April 12, 1989. *National Archives*

Right: Guests at the commissioning of the *Los Angeles*-class nuclear-powered submarine USS *Newport News* (SSN-750) walk under the city's Victory Arch on June 3, 1989. The arch is the principal monument of the city after which the submarine was named. *National Archives*

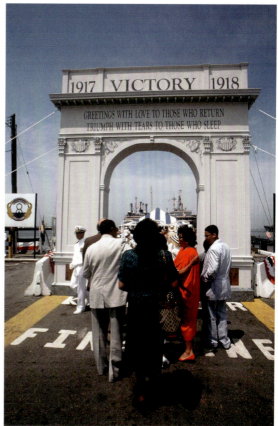

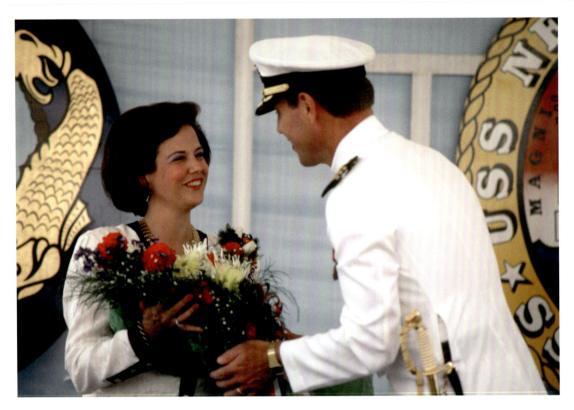

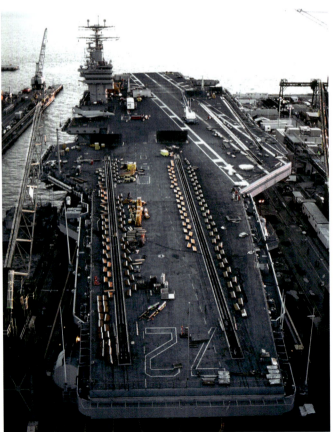

Above: Sponsor Rosemary D. Trible receives a bouquet from Commander Mark B. Keef, commander of the nuclear-powered submarine USS *Newport News* (SSN-750) at the commissioning ceremony held on June 3, 1989, at Newport News Shipbuilding. *National Archives*

Left: The nuclear-powered aircraft carrier USS *Abraham Lincoln* (CVN-72) lies in dry dock at Newport News Shipbuilding during its post shakedown cruise availability on May 1, 1990. *National Archives*

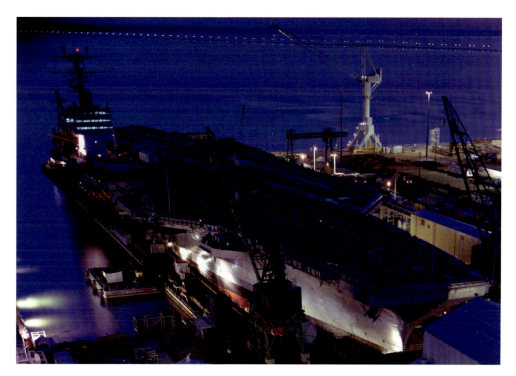

The nuclear-powered aircraft carrier USS *Abraham Lincoln* (CVN-72) lies in dry dock at Newport News Shipbuilding and was photographed in the early evening hours of May 11, 1990, during the carrier's post shakedown cruise availability period. *National Archives*

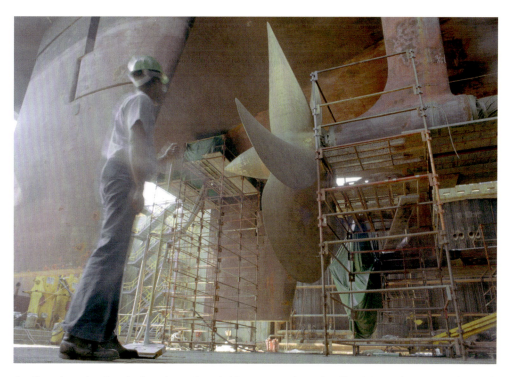

A sailor takes a break to look at the starboard side screw on the underside of the nuclear-powered aircraft carrier USS *Abraham Lincoln* (CVN-72). The *Lincoln* was in dry dock at Newport News Shipbuilding during its post shakedown availability period on April 25, 1990. *National Archives*

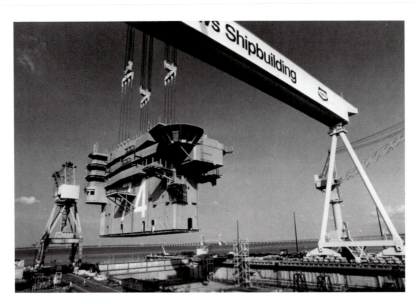

Affectionately called "Big Blue," this gantry-style crane at Newport News Shipbuilding stands 233 feet tall and has a span of 540 feet from leg to leg; it weighs 10.1 million pounds. "Big Blue" is shown here lifting the superstructure of the USS *John C. Stennis* (CVN-74) into position on the aircraft carrier in 1994. Built in 1976 by the German company Krupp, the crane's two legs straddle Dry Dock 1. On each side of the dock are a pair of rails that allow the entire crane to move up and down the ship's length. The payload is attached to a carriage on the main girder that can travel side to side. As originally installed, it could lift 900 to just under two million pounds, but in preparation for building today's larger aircraft carriers the shipbuilders needed to increase that capacity, which was done in-house at the shipyard. The crane today has a lifting capacity of just over 2.3 million pounds.

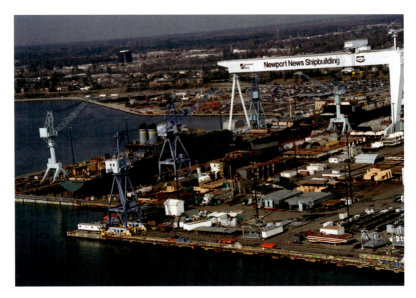

This is an aerial starboard quarter view of the Military Sealift Command's vehicle transport ship USNS *Gordon* (T-AKR-296) under conversion in dry dock number 12 at Newport News Shipbuilding and Dry Dock Company on the James River, taken on February 20, 1995. Forward of the *Gordon* is the amidship section of the nuclear-powered aircraft carrier USS *Harry S. Truman* (CVN-75). On the dock to the right can be seen various sections of the carrier under modular construction, including two of the ship's elevators. *National Archives*

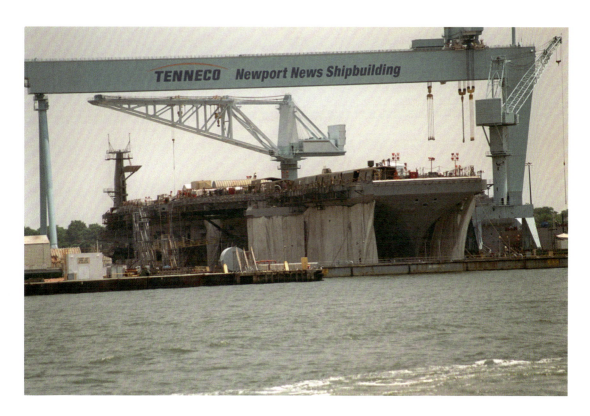

Above: The photograph shown here provides a starboard bow view of the nuclear-powered aircraft carrier *Harry S. Truman* (subsequently commissioned CVN-75) under construction on July 6, 1996, at the shipyard. *National Archives*

Right: Onboard the derrick barge *Wotanus*, personnel from the United States Navy, the National Oceanographic and Atmospheric Administration (NOAA), Phoenix International, and the Mariners' Museum look on after an underwater salvage device called a Spider was used to raise the revolving gun turret from the sunken Civil War ironclad USS *Monitor* onto the deck on August 5, 2002, during phase two of the Monitor 2001 Expedition. *National Archives*

First lady Laura Bush smashes a bottle of champagne against the bow of the *Virginia*-class attack submarine USS *Texas* (SSN-775) during the christening ceremony held at Newport News Shipbuilding, a Northrop Grumman yard at that time, on July 31, 2004. Pictured left is Tom Shievelbein, president, Northrop Grumman Newport News. *National Archives*

The participants for the cutting of the first piece of steel for CVN-78 (the *Gerald R. Ford*), the first ship of the CVN-21 future-generation aircraft carrier program, pose during a ceremony at Newport News Shipbuilding, then owned by Northrop Grumman Corporation, on August 11, 2005. The ceremony was held at the shipyard's new heavy-plate bay facility, one of several new structures built for the CVN-21 program. From left to right: Rear Admiral (lower half) H. Denby Starling II, commander, Naval Air Force Atlantic; Rear Admiral (lower half) David Architzel, commander, Operational Test and Evaluation Force and program executive officer for aircraft carriers; Joe S. Frank, mayor, city of Newport News; Mike Petters, president, Newport News Shipbuilding; Representative Jo Ann Davis (R-Virginia, First District); Representative Robert C. Scott (D-Virginia, Third District); Captain Michael E. McMahon, commanding officer, supervisor of shipbuilding. *National Archives*

Right: Northrop Grumman Newport News Shipyard—Newport News Shipbuilding—employees reattach a propeller to the number three shaft aboard the United States Navy *Nimitz*-class aircraft carrier USS *George Washington* (CVN-73). The ship has four brass propellers that are twenty-two feet in diameter and weigh 66,200 pounds. *Washington* was undergoing a docked planned incremental availability at the shipyard when this picture was taken on July 23, 2005. *National Archives*

Below: The Honorable Donald H. Rumsfeld, secretary of Defense (front left) speaks with Senator John Warner (right) (R-Virginia) before the christening of the *Nimitz*-class aircraft carrier USS *George H. W. Bush* at Newport News Shipbuilding (then owned by Northrop Grumman) on October 7, 2006, at Dry Dock 12, the largest in the western hemisphere. The *Bush* was completed in 2009. *National Archives*

Left: Carol M. Highsmith took this contemporary photograph of the bronze doorway detail at the Mariners' Museum. Museum founders Arthur M. and Anna Hyatt Huntington commissioned renowned American sculptor Herbert C. Adams (1858–1945) to create the large main entrance doors in the early 1930s. *Carol M. Highsmith Archive, Library of Congress*

Below: The United States Navy's *Virginia*-class attack submarine pre-commissioning (PCU) *Texas* (SSN-775) sails into the Northrop Grumman Newport News Shipyard—Newport News Shipbuilding—with the help of three tugboats after successfully completing Alpha sea trials on May 17, 2006. *Texas* was the second *Virginia*-class submarine and the first major navy combatant vessel designed with the post cold war security environment in mind. *National Archives*

Huntington Ingalls Industries' Newport News Shipbuilding division opened its new 90,000-square-foot Apprentice School, located at 3101 Washington Avenue in downtown Newport News on December 6, 2013. Apprentices, faculty and staff were joined for the opening by Virginia governor Robert F. McDonnell, United States congressmen Robert C. "Bobby" Scott and Robert J. "Rob" Wittman, Virginia delegate S. Chris Jones, Newport News mayor McKinley Price, Huntington Ingalls Industries president and chief executive officer C. Michael "Mike" Petters, Newport News Shipbuilding president Matthew J. "Matt" Mulherin, Armada Hoffler Holding Company president and chief executive officer Lou Haddad, and other business and community leaders at this celebratory event held at the front of the new school building. A thirteen-foot tall bronze sculpture cast by Eastern Shore artist David H. Turner was unveiled during the ceremony (shown here). *Huntington Ingalls Industries*

The *Virginia*-class submarine *John Warner* (SSN-785) (shown here) was launched into the James River on September 10, 2014, at Huntington Ingalls Industries' Newport News Shipbuilding division, kicking off the final outfitting, testing and crew certification phase of construction prior to sea trials. The *John Warner* represents the sixth *Virginia*-class submarine to be delivered to the United States Navy by Newport News Shipbuilding. From the start of construction in 2010, nearly 4,000 shipbuilders worked on the *Warner*. The submarine, the first *Virginia*-class submarine to be named for a person, was subsequently delivered to the navy in 2015. Once floating, the approximately 7,800-ton submarine was moved with the help of three tugboats to the shipyard's submarine pier, where final outfitting, testing and crew certification took place over the next six months. *Huntington Ingalls Industries*

Leon Walston, a Newport News Shipbuilding welder from Massachusetts, displays the welded initials of Caroline Kennedy, the sponsor of the aircraft carrier *John F. Kennedy* (CVN-79), during the ship's keel-laying ceremony at the shipyard on August 22, 2015. Also pictured (left to right) are retired rear admiral Earl Yates, the first commanding officer of the aircraft carrier USS *John F. Kennedy* (CV-67); Newport News Shipbuilding president Matt Mulherin; Virginia governor Terry McAuliffe, and Representative Joseph Kennedy III. The photograph was taken by Chris Oxley of Huntington Ingalls Industries. *Huntington Ingalls Industries*

The *Virginia*-class submarine USS *John Warner* (SSN-785) is pictured leaving Newport News Shipbuilding on sea trials as part of its post shakedown availability (PSA), completed on August 31, 2016, at which time it was redelivered to the navy. The *Warner* was the first PSA to be accomplished without having to put the boat into a dry dock for external hull work. The picture was taken by John Whalen. *Huntington Ingalls Industries*

Endnotes

1. When Newport News incorporated in 1896 it was one of only a few Virginia cities to be newly established without earlier incorporation as a town.
2. Joint Employee-Management War Production Drive Committee. *The Shipyard in Peace and War.* Newport News: Newport News Shipbuilding and Dry Dock Company, 1944.
3. Ibid.
4. The boundaries of the new city of Newport News were described thusly per the act of incorporation as beginning at a point at the low-water mark on the James River, where the center line of Fifteenth Street produced intersects the same; thence easterly along the said center line of Fiftieth Street to the westerly boundary line of the right of way of the Chesapeake and Ohio Railway Company; thence following the said right of way southwardly to the center of Thirty-sixth Street; thence eastwardly along the said center of said Thirty-sixth Street to the intersection of the center line of Madison Avenue; thence along the said center of Madison Avenue to the center line of Thirty-second Street; thence along the said center line of Thirty-second Street eastwardly to the boundary line between the counties of Elizabeth City and Warwick; thence with said county line southward to the intersection of the center line of Twentieth Street; thence along the center line of Twentieth Street westerly to the easterly side of the right of way of the Chesapeake and Ohio Railway Company to a point in the line with the southeastern boundary line of George B. West's property produced in a northeasterly direction; thence in a southwesterly direction along the said line of George B. West produced and with the said George B. West line to the low-water mark on the James River; thence along the low-water mark northerly to the point of beginning, in accordance with the map made of the city of Newport News by Walter A. Post, civil engineer; all of the said territory being in the County of Warwick, shall be deemed and taken as the city of Newport News, and said boundaries shall be construed to embrace all wharves, docks and other structures of every description that have been or may hereafter be erected along said waterfront; and the inhabitants of Newport News for all purposes for which towns and cities are incorporated in the Commonwealth shall continue to be a body politic in fact and in name under the denomination of the city of Newport News [...].
5. Joint Employee-Management War Production Drive Committee, ibid.
6. Works Project Administration Writers' Project–Virginia. *Virginia: A Guide to the Old Dominion.* New York: Oxford University Press, 1956.
7. Powell, Robert, "Shipbuilding company's new name is fitting tribute to its founder," *Virginia Business*, September 25, 2011.

BIBLIOGRAPHY

There were dozens of historical narratives, government documents and reports, programs, pamphlets and articles consulted in the crafting of the book. With limited space to convey a comprehensive bibliography, this is a select list of reference materials that were particularly helpful in the compiling of this pictorial history.

Books

Balison, Howard J. *Newport News Ships: Their History in Two World Wars.* Newport News: The Mariners' Museum, 1954.

Brown, Alexander C. *Newport News' 325 Years: A Record of the Progress of a Virginia Community.* Newport News: Newport News Golden Anniversary Corporation, 1946.

Harrison, Mitchell C., ed. *Prominent and Progressive Americans: An Encyclopædia of Contemporaneous Biography.* Volume 1. New York: New York Tribune, 1902.

Hawkins, Van. *A Pictorial History of Hampton/Newport News.* Virginia Beach: Donning, 1975.

Joint Employee-Management War Production Drive Committee. *The Shipyard in Peace and War.* Newport News: Newport News Shipbuilding and Dry Dock Company, 1944.

Martin-Perdue, Nancy J. and Charles L. Perdue Jr. *Talk About Trouble: A New Deal Portrait of Virginians in the Great Depression.* Chapel Hill: University of North Carolina Press, 1996.

Newport News Shipbuilding and Dry Dock Company. *Three Generations of Shipbuilding 1886–1961.* Newport News: Newport News Shipbuilding and Dry Dock Company, 1961.

Rouse Jr., Parke. *Endless Harbor: The Story of Newport News.* Newport News: Newport News Historical Committee, 1969.

—. *The Good Old Days in Hampton and Newport News.* Richmond: Dietz Press, 1986.

Tazewell, William L. *Newport News Shipbuilding—The First Century.* Newport News: The Mariners' Museum, 1986.

Whichard, Rogers Dey. *The History of Lower Tidewater Virginia.* Volumes I-III. New York: Lewis Historical Publishing Company, 1959.

Work Project Administration Writers' Project—Virginia. *Virginia: A Guide to the Old Dominion.* New York: Oxford University Press, 1956.

Yarsinske, Amy Waters. *Flyboys over Hampton Roads—Glenn Curtiss's Southern Experiment.* Charleston: The History Press, 2010.

Documents

National Park Service, National Register of Historic Places (registration form). "Aberdeen Gardens," March 2, 1994. National Register of Historic Places, May 26, 1994.
—."Hilton Village," 1969. National Register of Historic Places, June 23, 1969.
—."Hotel Warwick," August 21, 1984. National Register of Historic Places, October 4, 1984.
—."Saint Vincent de Paul Catholic Church," April 18, 2005. National Register of Historic Places, June 2, 2005.
—."Warwick County Courthouses," September 30, 1988. National Register of Historic Houses, November 3, 1988.
Old Dominion Land Company Business Records, 1881–1949. Local Government Records Collection, Newport News (City)/Warwick County Court Records. The Library of Virginia, Richmond, Virginia.

Websites

City of Newport News http://www.nngov.com/
Huntington Ingalls Industries http://www.huntingtoningalls.com/
Port of Virginia http://www.portofvirginia.com
Port Warwick.com http://www.portwarwick.com/portwarwick.html/
The Chesapeake & Ohio Historical Society http://www.cohs.org/
The Colony Inn http://greaterhiltonneighborhoods.org/ghn/imgs/docs/THECOLONYINN.pdf
United States Army Medical Department, Office of Medical History: http://history.amedd.army.mil/history.html
—.Chapter VII, "Port of embarkation, Newport News, Va." http://history.amedd.army.mil/booksdocs/wwi/wwivoliv/chapter7.htm
—.Chapter XXII, Embarkation and debarkation hospitals." http://history.amedd.army.mil/booksdocs/wwi/MilitaryHospitalsintheUS/chapter22.htm
—.Chapter XXXIV, "Newport News, Va. Debarkation Hospital No. 51 (General Hospital No. 43), Hampton, Va." http://history.amedd.army.mil/booksdocs/wwi/MilitaryHospitalsintheUS/chapter34.htm

About the Author

AMY WATERS YARSINSKE is the author of several bestselling, award-winning non-fiction books, most recently *An American in the Basement: the Betrayal of Captain Scott Speicher and the Cover-up of His Death*, a narrative that importantly continues the national conversation of POW/MIA accountability. The book won the Next Generation Indie Book Award for General Non-fiction in 2014. To those who know this Renaissance woman, it's no surprise that Amy Yarsinske became a writer. She learned at an early age that self-expression had to be forceful, accurate and relevant. This drive to investigate and document history-shaping stories—past and present—has already led to publication of over 70 non-fiction books covering current affairs, the military, historical narrative, biography and the environment. A graduate of Randolph-Macon Woman's College in Lynchburg, Virginia, where she earned her Bachelor of Arts in English and Economics, Yarsinske continued her education at the University of Virginia School of Architecture, where she earned a Master of Planning degree, and was a DuPont Fellow and Lawn/Range resident. She also holds numerous graduate certificates to include the CIVIC Leadership Institute and the Joint Forces Staff College, both headquartered in Norfolk, Virginia, and the Massachusetts Institute of Technology for a military course completed at Suffolk, Virginia. Additionally, she is also a Rotary Foundation Paul Harris Fellow. Yarsinske is a member of the American Society of Journalists and Authors (ASJA), Investigative Reporters and Editors (IRE), Authors Guild and the North Carolina Literary and Historical Association (NCLHA), among her many professional and civic memberships and activities.

If you want to know more about Amy and her books, go to www.amywatersyarsinske.com